the photographer's guide to
New York City

Where to Find Perfect Shots and How to Take Them

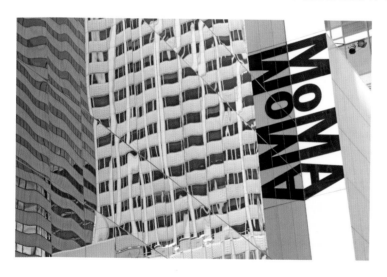

Steven Howell

THE COUNTRYMAN PRESS
WOODSTOCK, VERMONT

The Photographer's Guide to New York City
ISBN 978-0-88150-876-5

Cover photo by Steven Howell
Maps by Paul Woodward, © The Countryman Press
Book design and composition by S. E. Livingston

Published by The Countryman Press,
P.O. Box 748, Woodstock, VT 05091

Distributed by W. W. Norton & Company, Inc.,
500 Fifth Avenue, New York, NY 10110

Printed in China

10 9 8 7 6 5 4 3 2 1

*Title Page: Steel, glass, and sky highlight Midtown
Manhattan's photo ops, including the façade
of the Museum of Modern Art.
Right: Architecturally inspiring photo oppor-
tunities in Lower Manhattan include the
Municipal Building near City Hall.*

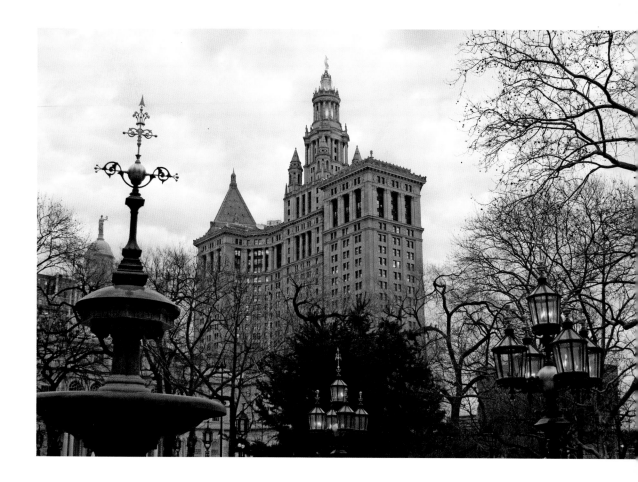

Acknowledgments

Very special thanks go to:

My favorite family from Long Island: Neal, Bob, Jenny, Bobby, and Emily Citro—sincere thanks for the crash pad and always keeping me very well fed! You are a beautiful family.

Jennifer Darienzo—travel companion extraordinaire and mysterious photo model.

Tony Munoz and Rick Bechard—for the company in New York and in the car on the way there.

Levi Berube—for your photographic suggestions.

My friends and colleagues at Countryman Press, including Kermit Hummel, Lisa Sacks, Ann Cortissoz, and Kim Grant.

New York City Tourism.

Public relations professionals throughout New York City.

And my friend Amir Doleh—a fine young photographer with a keen eye for architectural detail. I couldn't have done Brooklyn without you!

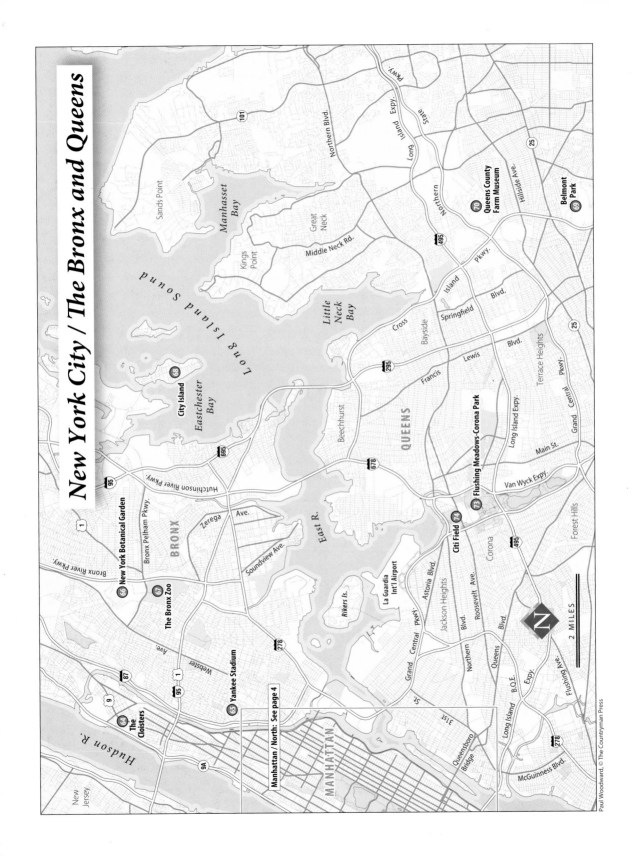

New York City / The Bronx and Queens

New Jersey

Hudson R.

The Cloisters 64

87

9

9A

The Bronx Zoo 67

New York Botanical Garden 66

Webster Ave.

Yankee Stadium 65

95

1

1

Bronx River Pkwy.

BRONX

Bronx Pelham Pkwy.

Zerega Ave.

Soundview Ave.

695

Hutchinson River Pkwy.

95

City Island 68

Eastchester Bay

Long Island Sound

Sands Point

Manhasset Bay

Kings Point

Middle Neck Rd.

Great Neck

Little Neck Bay

Cross

Bayside

Springfield

Lewis

Francis

101

495

Northern Blvd.

Long Island Expy.

Northern

Pkwy.

Island Pkwy.

Blvd.

295

678

Beechurst

East R.

Rikers Is.

La Guardia Int'l Airport

Astoria Blvd.

Jackson Heights

Grand Central Pkwy.

St.

QUEENS

Main St.

Van Wyck Expy.

Corona

Roosevelt Ave.

Blvd.

Queens Blvd.

Northern

B.Q.E.

Long Island Expy.

Flushing Ave.

McGuinness Blvd.

278

Citi Field 74

Flushing Meadows-Corona Park 73

495

Forest Hills

Terrace Heights

Grand Central Pkwy.

25

25

Queens County Farm Museum 70

Hillside Ave.

Belmont Park 69

278

Manhattan / North: See page 4

MANHATTAN

31st

Queensboro Bridge

N

2 MILES

Paul Woodward, © The Countryman Press

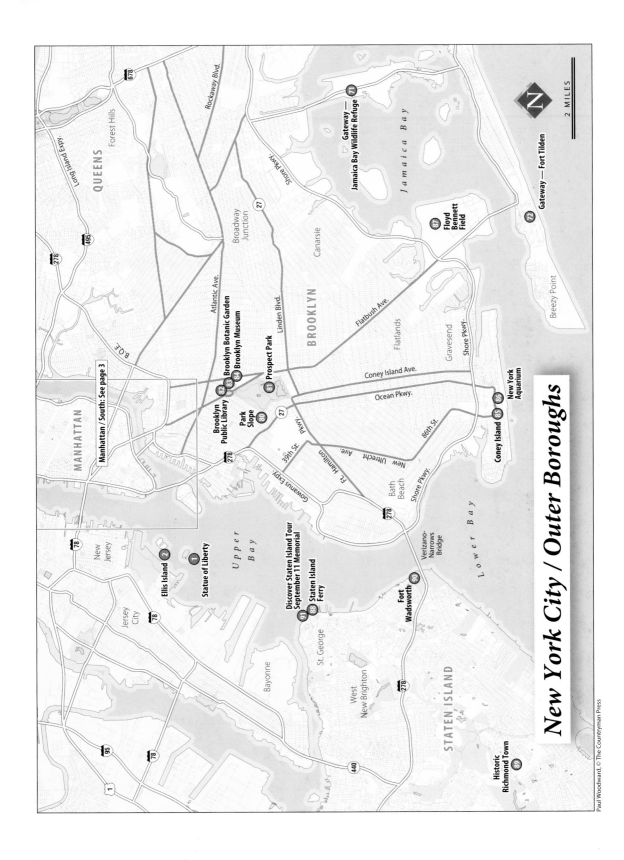

New York City / Outer Boroughs

N

2 MILES

678

QUEENS

Forest Hills

Long Island Expy.

Rockaway Blvd.

495

278

B.Q.E.

MANHATTAN

Manhattan / South: See page 3

Atlantic Ave.

Broadway Junction

Shore Pkwy.

27

Brooklyn Botanic Garden
83
Brooklyn Museum
84
82
Brooklyn Public Library
Prospect Park
81
Park Slope
80
27
Linden Blvd.

BROOKLYN

Canarsie

Flatbush Ave.

Flatlands

Gateway —
Jamaica Bay Wildlife Refuge
71

Jamaica Bay

Floyd Bennett Field
87

Gateway — Fort Tilden
72

Breezy Point

Coney Island Ave.

Ocean Pkwy.

Gravesend

Shore Pkwy.

Fort Hamilton Pkwy.

39th St.

New Utrecht Ave.

86th St.

Bath Beach

Shore Pkwy.

Coney Island
85 86
New York Aquarium

Gowanus Expy.

278

278

278

Upper Bay

Ellis Island
2

Statue of Liberty
1

New Jersey

78

78

78

Jersey City

Bayonne

Discover Staten Island Tour
September 11 Memorial
91
Staten Island Ferry
88

St. George

West New Brighton

STATEN ISLAND

440

278

95

78

1

Fort Wadsworth
90

Verrazano-
Narrows Bridge

Lower Bay

Historic Richmond Town
89

Paul Woodward. © The Countryman Press

Midtown & Uptown Manhattan

62 Grant's Tomb
61 Riverside Church
63 Harlem Apollo Theater
60 Columbia University
59 Cathedral Church of St. John the Divine
51 Central Park (north) Conservatory Garden
57 Cooper-Hewitt National Design Museum
56 Guggenheim Museum
55 Metropolitan Museum of Fine Art
50 Central Park (central) Belvedere Castle
53 Upper West Side Apartment Buildings: Dakota
58 Gracie Mansion
54 Whitney Museum of American Art
52 Lincoln Center
48 Columbus Circle / Time Warner Center
75 Noguchi Museum
17 Modern Skyscrapers of Note
32 Intrepid Sea, Air & Space Museum
49 Central Park (south) Horse-drawn carriages
43 American Folk Art Museum
44 Museum of Modern Art
46 Roosevelt Island Tramway
45 Citigroup Center
33 Westin Hotel
34 Lyric Theatre
35 Times Square
41 St. Patrick's Cathedral
42 Rockefeller Center
36 International Center for Photography
37 New York Public Library
38 Grand Central Terminal/Pan Am Building
31 Farley Post Office Building
39 Chrysler Building
40 United Nations Headquarters
30 Empire State Building

Hudson R.

New Jersey
New York

MANHATTAN

Central Park

East R.

Roosevelt Island

QUEENS

Lincoln Tunnel

Queens Midtown Tunnel

N

½ MILE

For other sites south of 30th Street, see page XX

Paul Woodward, © The Countryman Press

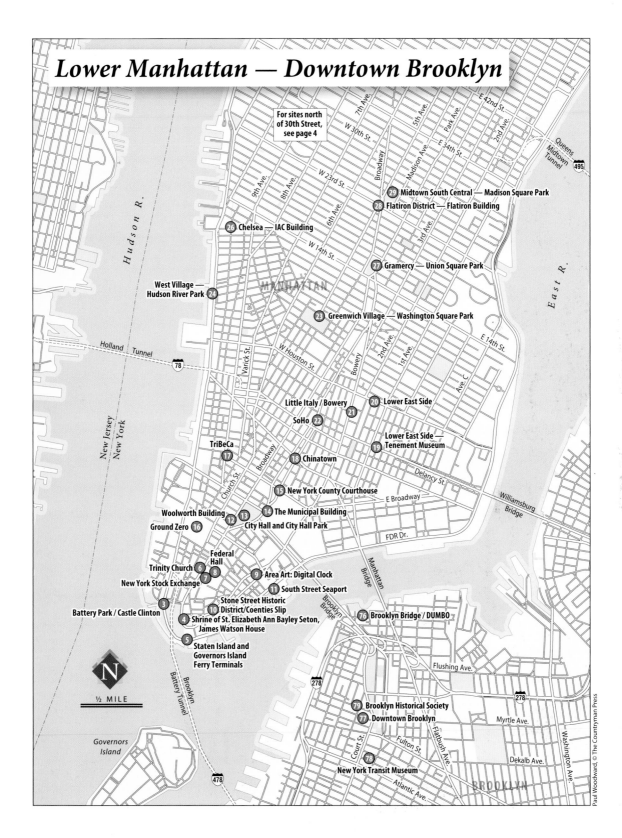

Lower Manhattan — Downtown Brooklyn

For sites north of 30th Street, see page 4

Hudson R.

East R.

New Jersey New York

MANHATTAN

29 Midtown South Central — Madison Square Park

28 Flatiron District — Flatiron Building

26 Chelsea — IAC Building

West Village — Hudson River Park **24**

27 Gramercy — Union Square Park

23 Greenwich Village — Washington Square Park

Little Italy / Bowery **21**

20 Lower East Side

SoHo **22**

Lower East Side — Tenement Museum **19**

TriBeCa **17**

Chinatown **18**

New York County Courthouse **15**

Woolworth Building **12** **13**

14 The Municipal Building

Ground Zero **16**

City Hall and City Hall Park

Federal Hall

Trinity Church **6** **8**

9 Area Art: Digital Clock

New York Stock Exchange **7**

11 South Street Seaport

3

Stone Street Historic District/Coenties Slip **10**

Battery Park / Castle Clinton

Shrine of St. Elizabeth Ann Bayley Seton, James Watson House **4**

76 Brooklyn Bridge / DUMBO

5

Staten Island and Governors Island Ferry Terminals

N

½ MILE

Governors Island

79 Brooklyn Historical Society

77 Downtown Brooklyn

78 New York Transit Museum

BROOKLYN

Holland Tunnel

Queens Midtown Tunnel

Williamsburg Bridge

Manhattan Bridge

Brooklyn Bridge

Brooklyn Battery Tunnel

FDR Dr.

E Broadway

Delancy St.

Flushing Ave.

Myrtle Ave.

Fulton St.

Dekalb Ave.

Atlantic Ave.

Cadman Plaza in Brooklyn

Contents

The Farley Post Office Building, shot at 1/250, f 8.0, ISO 100

Introduction

While trained as a writer first, photography has allowed me to explore the visual artistic side of my brain (besides being quite adept at drawing stick figures, I like to think I can take a decent photo). And in New York City, there are enough photo ops to go around for everyone.

Soaring skyscrapers offer architectural appeal and a sense of awe. World-famous landmarks add iconic history and vintage kitsch to the frame. Street scenes portray equal parts bustling urban life and refined city charm. And there are a few New York City surprises as well in the form of sand and surf, urban flora, and tranquil green oases that prompt a gentle reminder—I'm photographing New York City!

This is not an all-inclusive book but rather 100—and then some—of New York City's best photo subjects that inspire me the most. The entries include a well-balanced mix of fun tourist icons, inspiring city architecture, and serene green spaces all uniquely New York. It's impossible to mention all the photographic opportunities that New York City offers, but I think this is a good place to start. You will no doubt discover a few of your own favorites along the way.

All of New York City's boroughs are mentioned, and rightfully so. To the tourist: Visit a part of town or neighborhood that wasn't on your original travel itinerary. To the local: Venture to a nearby part of town that you've never before visited.

To both the visitor and the resident: Be prepared to be photographically inspired.

Financial District street scene

How to Use This Book

This book is geared toward photographers of all levels. Whether you're a point-and-shoot beginner, an avid amateur with your first digital SLR, or a serious pro who rises to the challenge of adding unique flair and perspective to a subject that's been photographed many times before—I've got some great suggestions for you all.

I've also listed some basic photo techniques. To the seasoned pro: While you may not learn anything new as far as technique is concerned, I will offer pertinent information such as lighting, best times of day to shoot, admission fees, commercial permit requirements, and a bit of history about each subject.

This book is not presented alphabetically but geographically by borough and neighborhood. Most of the suggestions can be shot year-round. In fact, you'll find that as lighting and environment (i.e. haze, leaves, and snow) change with the season, so will your photographs. A number of parades and festivals are included in case you're in town and want to shoot a specific event. I'm hoping you've already booked your hotel or are a local because you're on your own for accommodations. But I will mention a few restaurant suggestions—a photographer's got to eat, after all!

Tourist season runs throughout the year in New York and peaks summer through fall. That said, I've visited the observation deck of the Empire State Building during very early

spring with a few hundred of my closest tourist friends in search of a great view. The point here: For some iconic New York City shots, be prepared to wait in line.

Most of the photos in this book were shot spring through fall—I'm guessing that's when you'll probably be in town, if you are indeed a tourist. While winter shots are unique, if you don't capture that first blanket of snow, things tend to get dirty fast. Even still, there can be some beautiful winter weather without the snow in New York City.

I love spring for many reasons when photographing New York City. I specifically enjoy photographing city architecture when leaf buds are just about to bloom on the local trees—you simply get to see more of a particular building, and the trees don't look so bare. In addition, you can capture some intense blue skies during this season.

Summer offers lots to do and places to see, but unique lighting challenges. Beginning as early as May the sky can get quite washed out and hazy. This hot, hazy weather can last well into September. The autumn landscape adds dramatic fall foliage, particularly in Central Park and the outer boroughs.

For the accompanying photos sometimes the camera settings will be included—but not always. Lighting conditions change from season to season and from second to second—think a partly sunny day when a cloud quickly moves in. I don't want you to try and duplicate my settings, but instead to learn how to rely on your own here-and-now photographic instincts.

I take public transportation whenever possible. Pertinent subway stops are included with each entry. And I'll let you know which destinations I reached by car—mostly the outer boroughs. Directions are included.

And what you see is what you get. I received no special entry to the places I visited—for ex-

ample, private rooftop access. All of the vantage points within this book are open to the public with no special accommodations besides access fee (i.e. Top of the Rock). I also go heavy on the museums for a number of reasons: I am a self-proclaimed museum junkie, the exterior facades are usually worth photographing, and there's something to see inside once you're there. That said, permission might be necessary for photos to be used commercially. Obtaining written permission from the respective public relations department of your subject is suggested.

Souvenir T-shirts

How I Photograph New York City: Photographic Techniques

Buying a Digital Camera: Mega Pixels— Is Bigger Better?

In the market for a new camera? Taking better shots doesn't necessarily mean a bigger, better camera.

You don't have to buy the latest and greatest gear every time something new comes on the market—although the technology seems to improve monthly. Instead, consider the home of your photograph—this may help you decide what type of camera to buy.

Are you using your shots for a newspaper article, an art exhibition, or a stock photo agency? Each has different submission requirements. See what those photo editors require first. If you just want to share your photographs with family and friends, then use what you've got. If you currently use a point-and-shoot camera and are considering making the leap to a digital SLR—go for it. Quality camera equipment can be had for very reasonable prices. If you're looking to save money, last year's clearance models offer up-to-date technology at a less expensive price.

Welcome to the Digital Age

Congratulations on purchasing your new camera. Lesson number one: Read the instructions. You don't have to read that daunting 100-page instruction booklet all at once, but your digital camera can do some amazing things. Just take it one shot at a time.

Lesson number two: Get yourself good photo processing software, i.e. Adobe Photoshop. Once again, it may be an intimidating tool at first, but learn one new technique at a time. Not only can your camera do some amazing

things, the accompanying software can help clean up a variety of mistakes made in the field.

Resolution

High-res or RAW—what resolution setting is best for you? Again, finding the home for your photo will help you decide what res is best for you.

RAW files capture images in their purest digital form. The saved file lets you alter the image in many different ways after you've taken the initial shot. But RAW images take up a lot of space. If you need to do a lot of post-processing to adjust the photo for any number of reasons such as lighting, exposure, contrast or are using the photos in a professional way and have ample room on your computer—RAW is the way to go. That said, when I submit photos for my local newspaper assignments—and many for this book—a high-res jpeg is all that's required.

Some cameras take a jpeg and a RAW combo as well as a jpeg and a smaller RAW version, while some pre-selected settings won't capture RAW files at all. In addition, software to convert RAW to other file types is necessary. For personal photo scrapbooks, a large-file jpeg is fine.

Equipment that Comes in Handy & Proper Camera Care

Get yourself a good camera bag, one made specifically for the purpose. That extra padding goes a long way in case of an accident.

You probably bought your camera in a kit complete with a lens. Lenses can be quite expensive—sometimes more expensive than the camera. Invest in a decent walk-about lens, one

Columbus Circle

that you won't have to change often that covers a variety of wide-angle and zoom shots. Check your local photo store for some good deals on used lenses as well.

I love my tripod but I don't use it all the time. But if I'm shooting a specific shot planned in advance, and especially at dawn, dusk, or night, I always bring my tripod. I sometimes use an automatic shutter release. The camera can still shake during long exposure night shots even when it's mounted on a tripod simply because you've manually pressed the shutter. Don't have a tripod handy when you need one? Use what you've got—a fence, a lamppost, your body—even a friend's head! Those mini bendable, flexible tripods work in a pinch and are easy to store or even keep on the camera base.

To clean the lens I almost always go dry, using a micro cloth made specifically for that purpose. Occasionally an alcohol-based cleaner will rid the lens of accumulated dirt or water spray spots. Don't use your clothes to clean your lens as there's probably sweat and dirt on that T-shirt that's invisible to your eye. And change your lenses with the camera facing down in the cleanest environment you can find—you don't want the digital sensor getting dirty. If it does get dirty, save this cleaning job

for the professionals. A larger dry cloth helps wipe away any errant spray on the camera body.

As for filters: Sometimes I use them, often I don't—it's a personal preference. A polarizing filter can help reduce glare. A lens hood also helps prevent glare.

A back-up battery and one or two extra flash cards come in handy. I prefer high-quality flash cards (i.e. SanDisk Extreme).

I also carry a notebook and pen (the reporter in me) as well as a few photo releases.

Protecting Your Camera from the Elements

First, protect you camera from the elements, specifically the likes of rain or ocean mist. Then, embrace the weather.

I have the luxury of shooting and returning to the scene of the shot if I don't like what I got the first time around. But you, as a tourist, may be in town for a limited amount of time. What to do with unpredictable weather?

Try a different perspective or zoom in on an architectural detail if you don't want a washed-

Madison Square Park, shot at 1/125, f 8.0, ISO 100

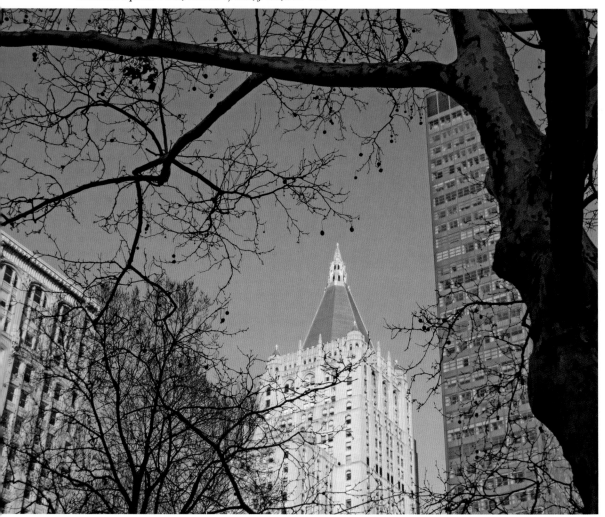

out sky in your shot. Blue skies are indeed beautiful, but a cloudy day can balance out lighting. Remember, fog can be fun, and never underestimate the power of a puffy cloud!

Things to Consider Before You Shoot

Rules of Composition—Rule of Thirds/Line/Shape/Balance/Mood/Storytelling

First ask yourself—what am I shooting? What is the subject? Pick a subject and then place it properly. Here's how.

Remember tic-tac-toe? Think of your photo as a rectangular tic-tac-toe board with nine boxes—like a grid. It doesn't matter if the shot is horizontal or vertical. In essence, you don't want your subject completely centered. You generally want the subject to fall near any of the corners of the center square. This offers balance and proper composition. That said, break the rules, get really close up, completely center something and see what happens—sometimes that works, too!

Use lines and perspective to help draw your eye to the "back" of a photo, i.e. a fence, a row of houses, a street, a skyline of buildings. When you change your angle, you change your perspective.

Photographs without borders: Take just a part of something. Capture a close-up of something big and let your imagination fill out the frame—it will.

A balanced (photo) diet: Add something in the foreground to balance out the background such as a bike path cyclist or a bright yellow cab in front of a city building.

Create a mood. Play with your aperture and focus on one particular subject while blurring out the rest of the photo. And don't be so quick with the flash—use existing lighting whenever you can.

Rely upon your intuition. Take a break from the automatic settings and tell the camera what to do—and not the other way around.

Finally, tell a story. One of my favorite shots is of two tourists, umbrella in hand, venturing out among the antiques stores in Old Quebec City. Nothing, not even bad weather, could keep them from a day of sightseeing and souvenir shopping. Don't be afraid to include people in your photos. Some are camera shy, yes. But others don't mind if you snap away. Either way, always get permission.

Visualization/Decisive Moment/Survival Tips on Cliché Subjects

Think before you shoot. In essence, slow down and take some time before you take that shot.

Scope out your subject. Are you shooting a stationary object like a building or a statue? Give it a complete front, sides, and rear walkabout.

Timing is everything. Are you shooting fireworks? Anticipate the explosion. A building often looks nice. A building with a passerby can sometimes look better. Get them in the shot as they walk by.

There are plenty of photo ops out there—even if it seems a subject has been shot to death. Try to be creative and change your point of view and perspective on life. Photographing children or animals? Come down to their level.

Try zooming in for architectural detail instead of taking the whole shot of that famed landmark.

In addition, look at your own portfolio. Do you tend to shoot more horizontally? Then turn that camera on its side and vary your shots between horizontal and vertical.

My favorite tip of all: Change the time of day you shoot. If you're not getting the shot you anticipated, walk away and come back later in the day or early the next morning—you may get the shot that people envy. I love dawn and particularly dusk because a little mood lighting can go

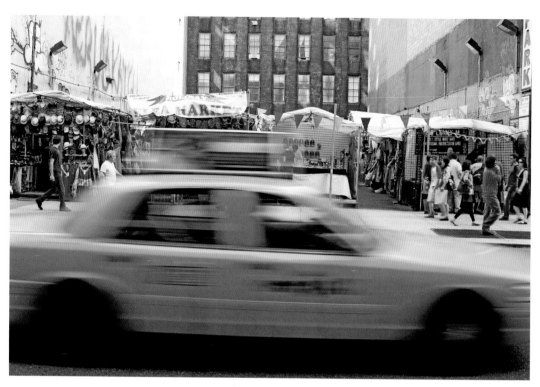

A taxi downtown

a long way—the camera can capture more light than your eye can see.

Play, play, play with your camera. Brainstorm, be creative, and experiment. And most of all have fun—you may be delightfully surprised with the result.

After You Shoot—Digital Post-Op Surgery for Photos: Exposure Adjustments

In a perfect photographic world, you take the shot, download it to your computer, and admire your awesome creativity. Well don't pat yourself on the back too fast. Unfortunately some of those photos may need a bit of cleaning up.

I can't tell you how often I thought I selected proper light settings and composition when capturing that perfect image—even with

viewing the LCD screen just after taking the shot (hey, on a sunny day that screen isn't always so easy to see—especially if you forget your glasses).

If you've underexposed or overexposed a photo—we all do it—don't fret. In the field, adjusting your F-stops will help balance the lighting. But if you didn't get the proper exposure settings out in the field, all is not lost. Play with Photoshop tools such as Curves and Levels to properly adjust exposure problems.

Cropping is an easy fix. You can eliminate an errant power line, ugly smokestack, or unseen garbage that made its way into your photo. Improve your photos by embracing the software technology and the things you can do after you've taken the shot. That said, don't spend all day being a Photoshop slave. Instead get out there and shoot.

Photo Ethics, Photo Releases, Photo Permits

Please be considerate of your surroundings, specifically the people you photograph (simply put, leave the paparazzi-style photo tactics for those dopes on TV—way too stressful for me—photography is supposed to be *relaxing*).

It's always a good idea to carry a few blank photo releases with you at all times (free forms are available online). Why? Because your eye for the public may legally be in the public eye—as long as you get permission. If you take a photo of someone—even if you took the shot in a public space—it's a good idea to get their written permission in case you want to reproduce their image for commercial purposes. In addition, be careful of corporate logos that crop into your shots if you're using the photo commercially.

Many museums and private properties require permission or permits when shooting commercial photography. These are best checked on an individual basis. Overall, use common sense when photographing strangers.

Keeping Track of What You Take

Before you know it a friendly little reminder alerts you that your flash card is full. Uh oh, time to download all those photos. And those photos do add up—a flash card can hold hundreds of photos at a time. New camera software and fast-processing computers make downloading a breeze. Naming each photo—now that's a different story (not that I'm a high-falutin' *artiste* or anything, but I've many photos titled "Untitled"). It pays to be diligent about downloading and properly labeling your photographs. Try labeling your folders and photos by date, place or subject—or a combination of the three. It's also OK to delete the duplicate and "bad" photos in your portfolio.

Practice and Patience

I take many photos when in the field—sometimes too many photos of almost the same subject. But with each new photo I'll vary the aperture, shutter speed, or automatic settings. Why? That good result from one shot can sometimes ensure a better result on the next shot (more specifically, less post-processing). Remember, automatic shooting is OK—especially to see what the camera is reading—but manual settings keep you in control. The bottom line: Learn these camera basics on your own equipment and have fun experimenting. And don't be so quick to delete while in the field. Embrace your photographic accidents; you may be delightfully surprised with the results when you're able to see the image on a larger screen.

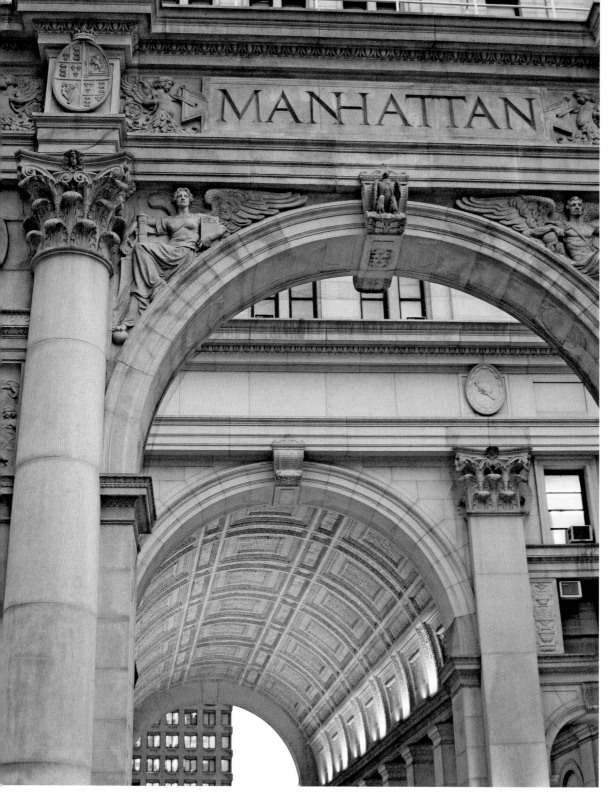

Municipal Building detail, shot at 1/8, ƒ 5.6, ISO 800

I. Lower Manhattan—Financial District and Civic Center

General Description: Lower Manhattan brims with American, New York State, and city history. It's a great introduction to the city as there is a lot to see, do, and photograph in a concentrated area. Save yourself a sightseeing day—or two—in this part of town. That said, be prepared to get a little lost; this grouping of gridless streets will sometimes leave you scratching your head and reaching for a map. This first chapter of photos meanders from points "west" to "east" and back again, but always moves from south to north. As the song says: "the Bronx is up and the Battery's down." We're beginning with the Battery and working our way north through Manhattan as the chapters unfold.

Directions: By Subway: The E train World Trade Center station gets you to Ground Zero, St. Paul's Chapel, and the Woolworth Building. The 1, R, and W to Whitehall Street/South Ferry stations bring you near Battery Park, the Statue of Liberty, and the Staten Island Ferry. The 4, 5, and 6 train to Chambers Street offers proximity to City Hall and the Brooklyn Bridge.

1. Statue of Liberty

The Statue of Liberty National Monument in lower New York Harbor, which is operated by the National Park Service, has greeted immigrants and symbolized America's freedom since it was received as a goodwill gift from France in 1886. It was created by sculptor Frederic-Auguste Bartholdi. Today, Lady Liberty welcomes some two million tourists every year. As

Where: the southern tip of Manhattan from about Chambers Street and below

Noted for: financial institutions, city government, modern skyscrapers, historic buildings, Lady Liberty, and hallowed ground

Exertion: minimal (for a lot of walking on level terrain—wear comfortable shoes or sneakers nonetheless)

Parking: It's New York City, so ditch the car. Instead opt for public transportation, taxis, or better still, walk.

Eats: South Street Seaport offers dozens of restaurants and eateries. Plenty of restaurants with outdoor terraces are situated along historic Stone Street. And Fraunces Tavern (54 Pearl St.) offers a Colonial-era photo op and iconic history with your meal—yes, George Washington did eat there. At about $20, their prix fixe lunch won't break the bank.

Public Restrooms: available at Castle Clinton in Bowling Green Park, Federal Hall, South Street Seaport, and the Staten Island Ferry Terminal

Sites Included: Woolworth Building, Ground Zero, Trinity Church, Stock Exchange, Statue of Liberty, Staten Island Ferry, the Brooklyn Bridge, and a bit of Wall Street Bull

Area Tips: Visit on the weekend if you prefer a less crowded atmosphere than you find on a weekday/workday. There can also be lots of bright sun mixed with tall building shadows, so be prepared to play with your aperture and exposure settings.

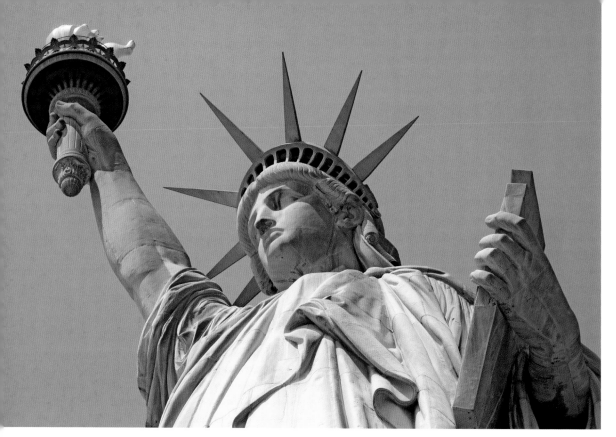

The Statue of Liberty, shot at 1/320, f 9.0, ISO 100

a local, it's one of the places you visit when: A) you're on a school field trip as a youngster; or B) friends and relatives come to town.

I had the opportunity to visit the Statue of Liberty under the latter circumstance when access was permitted inside the monument's crown during the 1990s. My friend and I ascended the 354 steps; the spiral staircase got narrower with each one. At one point we could only think of our dear ole moms—ex-smokers, a bit big in the behind—attempting the same feat. We laughed till we cried and temporarily stopped staircase traffic. It's a memory that will last a lifetime. Limited guided tours inside the crown are now available.

In this unfortunate post-9/11 age, many access restrictions to the Statue of Liberty apply.

Security screening is mandatory for ferry access. A monument pass is required for monument entrance, museum admittance, and access to the top of the pedestal. Monument visitors must pass additional screening. The monument access pass is free, but must be requested when purchasing your ferry ticket.

While tripods are allowed on site, extra bulky backpacks and bags are not. Keep your camera equipment to a minimum.

Lady Liberty is a wonderful photo op. Since the statue faces southeast, on a cloudless sunny day her face will be bathed in light during most of the park's operating hours (usually 9–5). A bright deep blue sky and the statue's oxidized green copper surface let you capture your own colorful glimpse of iconic history.

You'll need to time your trip accordingly.

Expect to wait 30 minutes to an hour just to purchase tickets and board the ferry during low season—and upward of two hours come summer. The official Web site suggests departing before 1 PM if you wish to get to both Liberty and Ellis Islands.

For an alternative adventure, a free round-trip Staten Island ferry ride offers two opportunities to capture Lady Liberty in the foreground of the New Jersey skyline. A telephoto zoom lens is necessary for this shot.

> Liberty Island ferry access is provided by Statue Cruises, which departs from Battery Park as well as Liberty State Park in Jersey City, N.J.
>
> Subway: 4 or 5 train to Bowling Green; 1 train to Whitehall-South Ferry; R or W train to Whitehall Street.
>
> Admission to the Statue of Liberty is free. The ferry costs about $12 for adults. Purchase ferry tickets at Castle Clinton National Monument in Battery Park or call Statue Cruises at 1-877-523-9849.
>
> Call 212-363-3200.
>
> Visit www.nps.gov/stli.

2. Ellis Island

After visiting the Statue of Liberty, continue your ferry ride to Ellis Island, which served as one of the nation's primary immigration processing centers from 1892 to 1954.

Ellis Island boasts a number of historic buildings to photograph, including the main immigrant processing center, now a museum, and a 1930s art deco-style ferry house—one of the more architecturally interesting buildings on site. Limited guided tours are available for the ferry house twice a day. Another 30 unrestored buildings, mostly medical facilities such as a quarantine station and medical personnel housing, remain off limits to visitors. Nonetheless, you can still easily capture the façade of a half dozen of these buildings from the ferry dock. Shots of the New York and New Jersey skylines can also be had from Ellis Island.

More than 12 million immigrants were processed at Ellis Island, so it's a good chance that your own relatives passed through these doors. An on-site genealogy program lets you search past ancestors—perhaps you come from a long line of photographers?

The Ellis Island ferry house, shot at 1/200, f 10, ISO100

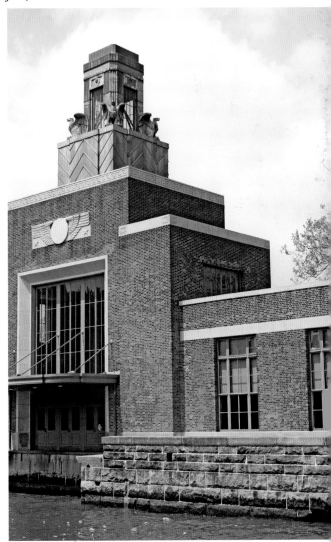

The same Ellis Island ferry fees, site access, and subway rules apply as the Statue of Liberty (see entry 1).

Call 212-363-3200.

Visit www.nps.gov/ellis.

3. Battery Park/Castle Clinton

Battery Park offers a small green respite for many financial district workers in need of a break come lunchtime. It also provides access to the Statue of Liberty and Staten Island ferries. Castle Clinton, which now serves as the ticket kiosk for the Statue of Liberty and Ellis Island Ferry, was once used as an immigration center for arriving ships.

Photographic subjects include a playful perspective shot along the main Broadway and Battery Place entrance as well as a seaside promenade view of Upper New York Bay. Passing ferries add foreground for a long view of the Statue of Liberty, but you'll need a telephoto lens. Other Battery Park monuments to capture include a grand bald eagle with back-stretched wings—it's part of the East Coast Memorial, which pays tribute to World War II servicemen. The centerpiece eagle is spectacularly highlighted among eight grand granite monoliths in the foreground and gleaming skyscrapers in the background. There's also the Korean War Memorial that depicts the silhouette of a combat soldier.

A current but temporary shot for the next few years includes *The Sphere* and its accompanying eternal flame. *The Sphere*, created by artist Fritz Koenig, once stood at the World Trade Center plaza. Battered and bruised from

The Sphere *in Battery Park as seen through Castle Clinton entryway*

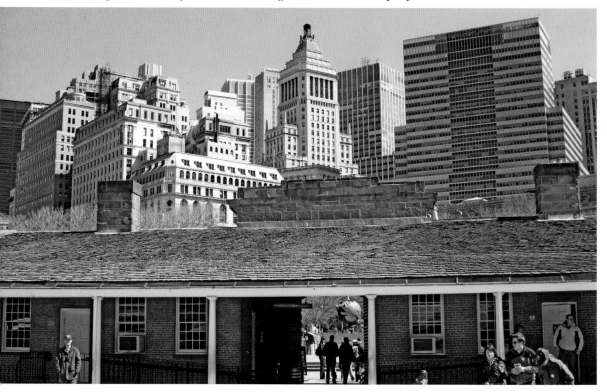

the attacks of 9/11, the sculpture remains intact and offers a poignant reminder of remembrance, hope, and better days to come. Frame *The Sphere* in the foreground of your shot facing Broadway and the magnificent façade of the Standard Oil Building (26 Broadway), a New York City landmark built in 1885 and expanded in the 1920s.

> Battery Park is at Battery Place and Water Street.
>
> Subway: 4 or 5 train to Bowling Green; 1 train to Whitehall-South Ferry; R or W train to Whitehall Street.
>
> Admission to the park is free, but be careful—the space seems a bit overrun with dozens of vendors hawking city souvenirs who just may finagle a T-shirt or snow globe sale out of you yet.

4. Shrine of St. Elizabeth Ann Bayley Seton and James Watson House

This New York City landmark, also listed on the U.S. National Register of Historic Places, includes two buildings: a church, now the shrine to St. Elizabeth Ann Seton, the first American-born saint, and the James Watson House, which dates to 1793. The house at separate times was the Seton family home as well as the residence of Watson, a former U.S. senator from New York from 1798 to 1800.

The interior of the shrine is understated and simple. Access is free. An exterior shot juxtaposes old and new New York, combining the church and the neighboring glass façade of the 42-story, curved 17 State Street Building, which was built in 1988. For frontal shots, the sun will be at your back in the afternoon. There is plenty of room to set up a tripod at the Staten Island Ferry terminal plaza across the street.

> Shrine of St. Elizabeth Ann Bayley Seton is at 7 State Street, between Pearl and Whitehall streets.

St. Elizabeth Anne Bayley Seton shrine, shot at 1/250, f 10, ISO 100

> Subway: 1 train to Whitehall-South Ferry; R or W train to Whitehall Street.

5. Staten Island and Governors Island Ferry Terminals

The Staten Island and Governors Island ferry terminals stand practically side-by-side in lower Manhattan across from the St. Elizabeth Ann Seton shrine mentioned previously and adjacent to Battery Park. The Staten Island terminal boasts a modern glass façade with big

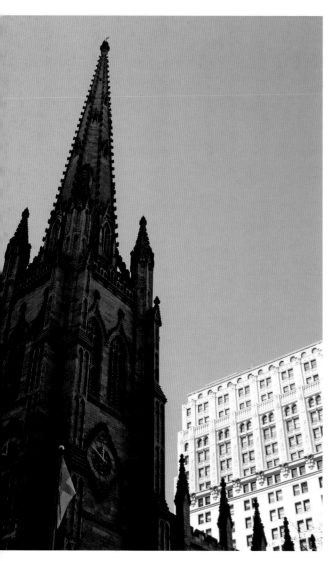

Trinity Church

ting sun creates a bit of glare. Play with a diffuser filter and wide angle lens or setting here. The ferry is free at all times for trips to Staten Island (see Chapter VIII).

Just next door is the Governors Island ferry terminal. Built in 1908, the steel structure is painted in muted gold and green tones and comes complete with ornate architectural details such as heavy metal doors, an exterior balcony, and peeling paint. The traffic is busy (it's a turnaround for Water Street taxis, buses, and cars) and there's barely enough space on the sidewalk directly in front. There is a very small parking area (for city officials only) where you can set up a tripod and wait for a passing cyclist, jogger, or bright yellow cab to add to the foreground.

> Budget-minded day-trippers can visit the park-like grounds of Governors Island every summer. Access and ferry are free (visit www.govsisland.com).
> Subway: 1 train to Whitehall-South Ferry; R or W train to Whitehall Street.

6. Trinity Church

With its grand ornate central spire and brownstone façade, gothic revival architectural elements define the magnificent Trinity Church. No doubt the darker central and nave spires bathed against a bright blue sky will create havoc with your exposure settings: Just be patient—you're at church! Play with the settings, move about the churchyard grounds (open during the day), say a little prayer, and snap away.

The original Trinity Church was constructed in 1698 and was destroyed in the New York City fire of 1776. A second church lasted a few decades but was torn down after snowstorm damage. This current church dates to 1846.

The on-site centuries-old churchyard with its distinctively shaped tombstones offers abundant displays of perspective. Trees shade the yard spring through fall. Alexander Hamil-

bold letters announcing "Staten Island Ferry." The letters are lit neon blue come evening and nighttime. The plaza remains a great place to capture a bustling scene of commuters on their way to and from work.

Morning light hits the building's front entrance and left side. When facing the terminal the sun will hit you straight on by midday. The neon lights come on at dusk, but again the set-

ton and steamboat inventor Robert Fulton are buried here. Be aware that you may have to compete with the many locals who pull up a park bench and visit during lunchtime.

You can practice shots of perspective by walking down Wall Street with Trinity Church as your focal point. (Construction cranes occasionally creep into the background shot.)

Interior shots allow for ornate moldings and colorful stained glass but be considerate of parishioners as Trinity Church remains an active parish.

Trinity Church is at 79 Broadway at Wall Street.
Subway: 2 or 3 train to Wall Street; N or R train to Rector Street.
Call 212-602-0800.
Visit www.trinitywallstreet.org.

7. New York Stock Exchange

Many Wall Street movers and shakers call the New York Stock Exchange building home every Monday through Friday. You'll find the main building of the NYSE, a designated National Historic Landmark, at the corner of Broad and Wall streets—just look for the great big American flag. And oh, what a big flag it is; it's draped across the façade's six stately columns. Sometimes the flag is depicted in a light display.

Magnificent and intricate marble statues just above the columns add to the elegant front of this neo-classical building, which was built in 1903. Pedestrian-only Broad Street offers enough room to move about and capture the façade from a variety of angles. However, you will encounter challenges of light and shadows on any sunny day; the sun peaks along Broad Street for a short spell early in the afternoon.

New York Stock exchange is at 11 Broad Street between Wall Street and Exchange Place.

Subway: 2 or 3 train to Wall Street; N or R train to Rector Street.

8. Federal Hall

Operated by the National Parks Service, Federal Hall National Memorial offers iconic American History 101. The original building claims dibs to a number of historical facts: It served as City Hall in the 1700s; was home to the first U.S. Congress and Supreme Court (New York was the nation's capital then); was where the Bill of Rights was drafted; and was also where George Washington was sworn in as the first president of the United States in 1789 on an open-air balcony. Imagine George sneaking a peak to his right. Now, as then, he'd see the same thing as you—a view of Trinity Church (although George would have seen the

A statue of George Washington stands guard at Federal Hall.

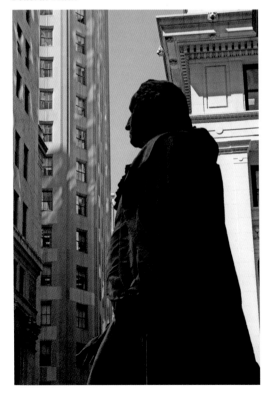

original church (see entry no. 6). This current Federal Hall building, first a Customs House, dates to 1842.

That is indeed President Washington captured in bronze on the front steps, and it's a shot that's been taken a million times before. Make it your own. Climb the stairs and get up to George's level to capture his silhouette with either Trinity Church or the New York Stock Exchange in the background—this way you'll capture two New York City icons in one. George and the building's façade, which face south, get directly bathed with sunlight in early afternoon.

The on-site museum always features a small but worthy historically themed exhibition or two, and best of all, it's free. Interior shots with flash are allowed, and the small rotunda makes for an understated photographic subject.

Professional photographers must pay a $50 permit fee if taking a shot from the steps. You're good if the shot originates from the sidewalk. (Also see the Grant's Tomb entry no. 61).

> Federal Hall is at 26 Wall Street between Nassau and William streets.
> Subway: 2 or 3 train to Wall Street; N or R train to Rector Street.
> Admission is free. Open weekdays.
> Call 212-825-6990.
> Visit www.nps.gov/feha.

9. Area Art: *Red Cube /Charging Bull / Digital Clock*

Inspirational public art abounds in New York City—you can often find pieces at building plazas. Here are three of my favorites to photograph and some examples of what you'll find downtown.

The financial district's digital clock, shot at 1/100, f 6.3, ISO 400

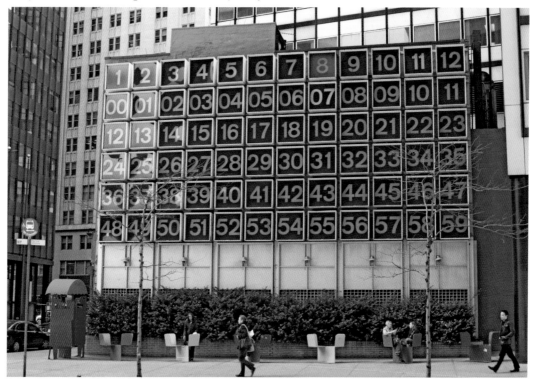

Sculptor Isamu Noguchi's 1968 *Red Cube* appears to have fallen from the sky and landed directly on its point. The bright red pops against the dark glass of the Marine Midland Bank Building (now HSBC Bank Building) at 140 Broadway. I love the fact that so many New Yorkers just walk on by and seem totally oblivious to the piece (jaded New Yorkers? Nah. They're just busy). More sculptural photos ops are available at the Noguchi Museum in Queens (see entry no. 75).

The financial district's infamous bull, officially named *Charging Bull,* was created by artist Arturo Di Modica. It boasts a most intriguing story of guerilla art—which is sometimes the way it should be.

Di Modica spent his own money to cast the bronze bull. He then covertly installed it in front of the New York Stock Exchange building one night in 1989. The bull got confiscated but the public demanded its return. City officials obliged and gave it a permanent home in Bowling Green Park along Broadway near Wall Street. It's now one of the most photographed icons of New York City. Good luck capturing it without a smiling tourist nearby. Incidentally, check the bull's balls. If they appear a bit shinier than the rest of the piece, it's because folks just can't get enough of fondling the bovine's best Wall Street assets for a bit of good luck. And that's no bull.

Incidentally, the building in the background of the bull when facing south is the Alexander Hamilton Custom House, a truly fine example of Beaux Arts architecture. It's now home of the Smithsonian National Museum of the American Indian New York branch.

Finally, artist Rudolph de Harak's 45-by-50-foot digital clock at the corner of John and Water streets has a wonderful '70s sensibility, complete with a small plaza of metal chairs colored in primary reds, yellows, and blues. The clock hasn't kept proper time in years but re-

mains a Financial District fixture and one worthy of photographing.

10. Stone Street Historic District/Coenties Slip

Find your way to the Financial District pocket of streets and alleyways near Stone Street, Coenties Alley, Coenties Slip, William Street, and South William Street. Here you'll find a mix of old and new, high-rise and low-rise, a bit of grit, photographic challenges of light and shadows, and plenty of perspective.

Stone Street, one of the oldest streets in town, complete with cobblestone (Stone Street, get it?), is a pedestrian-only alley that offers plenty of restaurants with outdoor seating when the weather gets nice.

The row of buildings near 15 South William Street offers neo-Flemish façades inspired by the time when the Dutch ruled town.

The Flatiron-esque, triangular Delmonico's steakhouse sits at 56 Beaver St.

And the skyline view of Coenties Slip at Water Street offers a mix of new skyscrapers in the background including the Morgan Bank Building and a row of older low-rise architecture complete with iconic New York City graffiti (I'm most happy that I made it to the 10th entry before mentioning the word *graffiti!*).

Subway: 1 train to Whitehall-South Ferry; R or W train to Whitehall Street.

11. South Street Seaport Historic District

The South Street Seaport Historic District adds a variety of maritime flair to your photos.

Start at Schermerhorn Row at 2 to 18 Fulton St. to capture the Federalist-style row of Federalist brick buildings known as counting houses, which date to 1811 and 1812. They once provided warehouse space for local merchants. Today the buildings host the South Street Seaport Museum. While the buildings

Coenties Slip in the Stone Street Historic District, shot at 1/200, f 10, ISO100

remain centuries old, the area caters to tourists and looks a bit polished, complete with a variety of retail stores.

Cross underneath the elevated FDR Drive to Pier 17 and the Seaport proper. Here you'll find views of the Brooklyn Bridge on the upper deck overlooking the East River—add the lounge chairs for some foreground fun. From here the sun casts light facing the bridge in mid- and late afternoon.

Other notable photographic subjects in the area include the museum's resident fleet of ships, which include among them the *Peking* and the *Wavertree*, two authentic tall sailing ships docked between Piers 15 and 16. The entire area adds a bustling mix of tourists and locals come high tourist season and every weekday lunch hour. The seaport also provides restaurants, a food court, and clean restrooms.

Incidentally, the Fulton Fish Market is no longer in the neighborhood. It moved to the Hunt's Point section of the Bronx in 2005.

At South and Fulton streets.
Subway: 1, 2, or 3 train to Fulton Street.
Visit www.southstreetseaport.com.

12. Woolworth Building

There are many grand edifices around town where you'll simply pause and say, "They just don't make 'em like that anymore." The Woolworth Building is one of them.

Opened in 1913, the Woolworth Building was commissioned by Frank Woolworth, the head of the iconic five-and-dime discount retail chain. The building cost $13.5 million and it's a known fact that Woolworth paid in cash—now that's a lot of nickels and dimes.

At 57 stories, or 792 feet tall, the Woolworth

Building reigned as the tallest building in the world until 1930. It was designated a National Historic Landmark in 1966.

Evoking a grand cathedral, the building offers an inspirational Neo-Gothic-style façade with art deco ornamental architectural details throughout. The lobby is said to be equally as ornate, but unfortunately in this post-9/11 world, as with neighboring City Hall and many Manhattan office buildings, access inside is only allowed if you work there (TV's *Ugly Betty* does—look for the building in the show's opening credits).

City Hall Park across the street offers a roomy vantage point from which to shoot the Broadway entrance and façade. Morning shots will leave the sun at your back. That said, the building offers the same ornate details on all sides, letting you capture the structure any time of day with varying foreground and background elements.

It's hard to squeeze all that splendor into the shot, so you may want to concentrate on the upper floors, specifically the magnificent pyramidal crown. A zoom lens comes in handy for these close-ups.

Woolworth Building is at 233 Broadway. Subway: 2 or 3 train to Park Place.

13. City Hall and City Hall Park

City Hall is indeed where the mayor of New York City conducts all of his business (he has

South Street Seaport maritime muscle, shot at 1/250, f 11, ISO 100

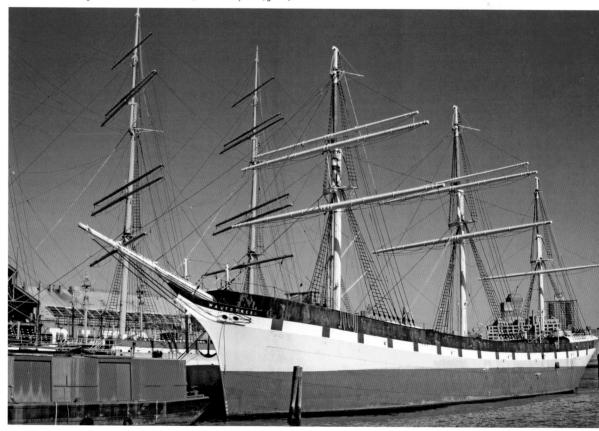

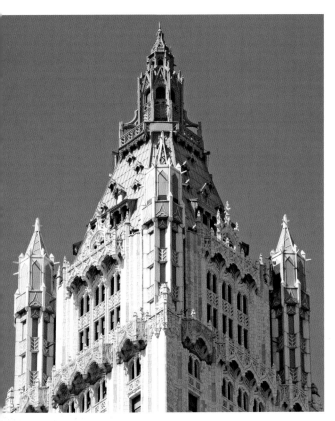

The Woolworth Building

the option to live at Gracie Mansion—see entry 58). I say "his" and "he" because since 1665, when Thomas Willet was appointed the city's first mayor—and some 113 mayors have followed—a woman has never held the office.

The building, which dates to 1811, offers a French Renaissance exterior. I hate to sound like a broken record, but the building is off limits to visitors and encircled by a wrought-iron fence. That said, you can still take a photo through the fence.

City Hall Park offers a small greenspace foreground with centerpiece fountain in which to capture the Woolworth Building (mentioned above) in one direction, and the Municipal Building (mentioned next), complete with authentic gas-powered vintage street lamps.

While I couldn't photograph the building in time for the book because it was under construction, look to 8 Spruce St. to find the Beekman Tower, a 76-story skyscraper designed by architect Frank Gehry that's sure to add dramatic punch to the Lower Manhattan skyline shot.

City Hall Park is bordered by Broadway, Park Row, Centre Street, and Chambers Street.
Subway: 4, 5, or 6 to Brooklyn Bridge-City Hall.

14. The Municipal Building

Hands down, the Municipal Building is one of the most beautiful buildings in the city.

Designed in an Italian Renaissance style, the building dates to 1914 and offers a photo-op that is jaw-droppingly inspirational. Trust me, you'll spend half the afternoon trying to capture it just right. Stick around for dusk and capture the archway all aglow. Not only will the building inspire you, it also inspired Joseph Stalin, who commissioned seven buildings known as Moscow's Seven Sisters in a similar style in the early 1950s.

Architectural details include a central triumphal archway inspired by Rome's *Arch of Constantine,* grand Corinthian columns and pilasters, soft-hued granite façade with ornate reliefs, pinnacled turrets, and a wedding cake–style central tower complete with crowning statue called *Civic Fame*—it's got it all. But whatever city official placed that visible satellite dish on the roof and allowed for air conditioners protruding out the windows is obviously not a photographer.

Shots directly in front are difficult if you wish to squeeze in the entire façade. Most often the building is photographed from the front and southern side when standing adjacent to City Hall or in City Hall Park across the street. Afternoons offer the best lighting, with

the sun at your back. Shots of the rear aren't as photogenic but are more easily accessible on the nearby Brooklyn Bridge and best when taken in the morning hours.

> The Municipal Building is at 1 Centre Street.
> Subway: 4, 5, 6, J, M, or Z train to Centre Street.
> From here take an optional side trip across the Brooklyn Bridge (see Chapter VII, Brooklyn).

15. New York County Courthouse (NY State Supreme Court)

Hollywood loves the ubiquitous New York City Courthouse. Where have you seen this building before? To name a few, *Miracle on 34th Street, 12 Angry Men, Kramer vs. Kramer, The Godfather, Wall Street, GoodFellas, Kojak, Cagney and Lacey, NYPD Blue,* and *Law & Order.*

This six-sided, Roman classical masterpiece, complete with 10 Corinthian columns and a 100-foot-wide flight of stairs, was designed by architect Guy Lowell. You'll need a wide-angle lens setting (the lower mm number on your lens: 35, 24, or 18) to capture it. It opened in 1925.

Just in front at Foley Square, artist Lorenzo Pace's sculpture *Triumph of the Human Spirit* and its fountain base add foreground abstract punch to the shot. There's enough room in

New York County Courthouse

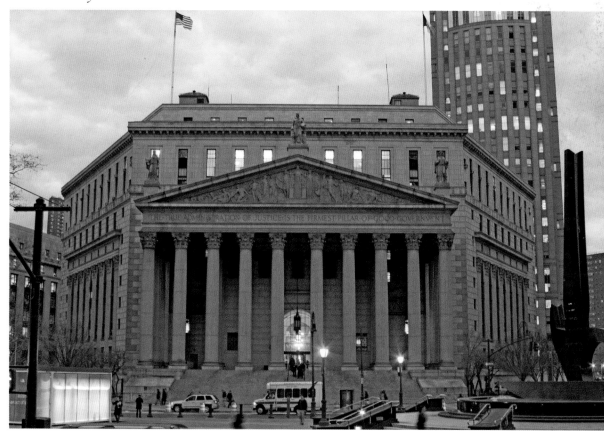

Foley Square to set up a tripod and play in the area for a while. Afternoon shots leave the sun at your back and to the right when facing 60 Centre St. The U.S. Courthouse, just next door at 40 Centre St., is equally impressive and adds more majestic columns and a longer view of perspective facing north along Centre Street between Duane and Reade streets.

> New York County Courthouse is at 60 Centre Street.
> Subway: 4, 5, 6, J, M, or Z train to Chambers Street.
> Continue northbound along Centre Street and you'll soon be in Chinatown.

16. Ground Zero/St. Paul's Chapel/ Barclay-Vesey Building

Ground Zero is the place where the World Trade Center's Twin Towers stood before the attacks of September 11, 2001. The site still draws many visitors who often photograph their own piece of tumultuous history.

I fondly remember traveling to the World Trade Center observation deck on a high

The Barclay-Vesey Building

school field trip and with out-of-town friends. The Ground Zero site still leaves me speechless. My mind's eye will always fill in that skyline void where the Twin Towers once soared —that's a photograph no one can destroy. The photo op here is yours to capture any way you wish.

What's to come on the site looks awfully promising—six buildings in all including the centerpiece Freedom Tower (which may be undergoing a name change), a futuristic transportation hub, and a fitting memorial (check the Port Authority Web site at www.panynj .info). Unfortunately the project has been delayed more than once.

The immediate vicinity offers reminders of that day and the restoration that took place after. St. Paul's Chapel and the Barclay-Vesey Building are two examples.

St. Paul's Chapel (209 Broadway), which stood just across from the Twin Towers, remained uncannily unscathed by the attacks. The site became a makeshift shrine to the victims of the day; many items left at the shrine remain today. Exterior shots offer similar light exposure challenges when combining the darker façade against a bright sky to those at Trinity Church, mentioned previously.

The Barclay-Vesey Building (140 West St.—you're now at the southern border of TriBeCa), once home to New York Telephone and now the Verizon Building, was built in 1923 and its exterior offers sumptuous art deco flair. A portion of the façade was severely damaged in the attacks, but the building was completely restored down to its intricate limestone carvings.

> Ground Zero is bordered by Vesey, Church, Liberty, and West streets.
> Subway: E train to World Trade Center; R or W train to Cortland Street.

II. Downtown Manhattan—The Neighborhoods

General Description: The area between Lower and Midtown Manhattan offers a residential neighborhood feel. That translates to typically bustling street scene photo ops that feature a bit of unpolished urban grit. The residential designation also means a number of great restaurants. Each entry here comes with a short description of the neighborhood, its location, and a highlighted photo op or two in each. If time is limited, choose at least one or two of these neighborhoods to capture true New York City essence and photo flair.

The High Line in the Meatpacking District

Where: the area above the Financial District and City Hall and below 34th Street, as well as from the Hudson River to the East River

Noted for: busy street scenes, colorful Chinatown accents, fire escape abstracts, cast-iron buildings, artsy museums inside and out, tenements, iconic storefronts, and views of perhaps two of the most photographed buildings in the world, with another one soon to be added to that illustrious list

Exertion: Minimal to moderate—for walking on mostly level terrain but there is a lot of ground to cover. I offer a "moderate" exertion level because by the end of the day your feet will need a well-deserved soaking.

Parking: Again, opt for public transportation.

Sleeps and Eats: the iconic Chelsea Hotel; affordable Tex-Mex at Cowgirl (see entry 24); audacious barbeque at RUB (see entry 28); informal hot and cold buffet at Café 28 Gourmet Deli (see entry 29); dozens of masterpiece Meatpacking meals (see entry 25); and pickles! (see entry 20)

Public Restrooms: Tenement Museum ticket lobby, Angelica Film Center (at Mercer and Houston streets), and any Starbucks throughout the city will do, too

Sites Included: Flatiron Building, great views of the Empire State Building, the IAC Building designed by Frank Gehry, Washington Square Park Arch

Area Tips: This chapter's neighborhoods, aside from Chelsea and Gramercy, don't abide by Manhattan's grid systems of streets. Be prepared to occasionally make a wrong turn and get a little lost.

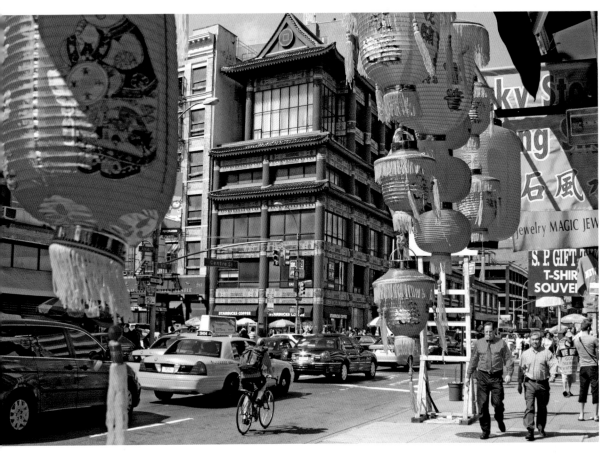

Chinatown, shot at 1/160, f 9.0, ISO 100

Directions: These neighborhoods start near Chambers Street and meander westward, then eastward, but always northward. There are dozens of subway options in this part of town. Suggested stops are included with each entry.

17. TriBeCa

The Triangle Below Canal Street, better known as TriBeCa, has enjoyed the neighborhood moniker since the 1960s. TriBeCa proper is bordered by Canal Street to the north, the Hudson River to the west, Broadway to the east, and Vesey Street to the south. It's the perfect example of how simply crossing the street lands you in a different neighborhood: the Civic Center area along Broadway, Greenwich Village to the north of Canal Street, and the Financial District south of Vesey Street.

This residential neighborhood offers warehouse buildings converted into lofts and condos, plenty of restaurants, the popular TriBeCa Film Festival, and is home to a few celebrities. Famous Tribecans include Robert De Niro (enjoy lunch and spot a supermodel at his tony Tribeca Grill, 375 Greenwich St.).

Architecturally inspiring buildings of note include the ornate art deco styling of the Western Union Building at 60 Hudson St.; the former New York Mercantile Exchange Building with its beautiful brick tower at 6 Harrison

St.; the lovely Beaux Arts Powell Building at 105 Hudson St. and a row of Federalist-style houses complete with cobblestone paving along Harrison Street near Greenwich Street.

Subway: 1 train to Franklin or Canal streets.

18. Chinatown

Venture east from TriBeCa, north of the City Hall area, south of SoHo, and west of the Lower East Side, and you'll find yourself in Chinatown. The ever-expanding neighborhood offers a number of photo ops such as storefronts complete with colorful hanging lanterns and an abundance of signs adorned in the authentic characters of the Chinese alphabet.

Chatham Square near East Broadway offers the Kim Lau Memorial Arch and a statue of Lin Ze Xu, a 19th-century Ching Dynasty Chinese drug czar known for his opposition to opium. Local musicians often play in Columbus Park near the intersection of Mosco, Worth, and Baxter streets. And Canal Street is home to the Mahayana Buddhist Temple (133 Canal St.), which displays a busy street façade of buildings and billboards worthy of a photograph.

Continue along Canal Street to discover dozens of shops hawking imitation Prada, Coach, and Dolce & Gabbana bags (name a brand, there's a knock-off). Discretion with the camera is a must if you're "window shopping" in the area.

For a further exploration of the neighborhood, walking tours are available through the Museum of Chinese in America at 215 Centre St. (212-619-4785, www.mocanyc.org).
Subway: 6, J, M, N, Q, R, W, or Z trains to their respective Canal Street station.

19. Lower East Side—Tenement Museum

The Lower East Side was, and still is, home to many immigrants who moved to the United States in search of a new life. A good place to start to capture the essence of the neighborhood is the Tenement Museum.

The museum offers guided tours at 97 Orchard St. in a tenement building that dates to 1836. Tours tell the story of some of the actual 7,000 tenants who once called the building home. The dilapidated interior remains intact and depicts substandard living conditions, complete with crumbling plaster walls, peeling wallpaper, and period fixtures and furnishings. Unfortunately, photos are not allowed inside, but the museum hosts 90-minute walking tours of the area where you can learn about city and immigrant history and snap away. A dozen stops and photo ops along the way include synagogues, churches, schools, and storefronts in addition to any number of fire escapes that create some wonderful photographic abstracts. Be prepared for some challenges of light and shadow cast by the area's buildings.

The on-site museum store offers a well-stocked selection of New York City–themed photographic books and inspirational postcards.

Lower East Side, shot at 1/200, f 9.0, ISO 100

Tenement Museum is at 108 Orchard St. (museum store and ticket lobby).

Subway: F train to Delancey Street; J, M, or Z train to Essex Street.

Guided tours cost about $17 for adults. Check online for reduced admission during low season visits.

Call 212-982-8420.

Visit www.tenement.org.

20. Lower East Side—Storefronts, Food, & Photo Ops Tour

Food with your photos? Here's a great way to explore the Lower East Side—eat and photograph your way through it. The area offers some tasty delicacies and vintage photogenic storefronts. Just bring some extra napkins.

The Yonah Shimmel Knishery has been around since 1910. The colorful storefront looks as if it hasn't changed a bit (and look at the two signs—the last name is spelled two different ways: Schimmel and Shimmel!).If you've never had a knish, a delectable concoction of mashed potato enveloped in a crusty dough, now's the time to try one—with a little salt and spicy mustard, of course. At 137 East Houston St.

The Katz's Delicatessen corner storefront offers neon lighting, a kaleidoscope of street signs, colorful window art that states: GOD

Lower East Side storefront, shot at 1/80, f 5.6, ISO 100

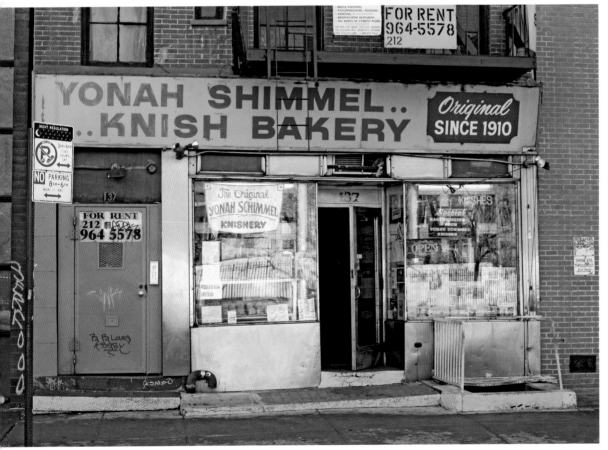

BLESS THE L.E.S., and succulent pastrami on rye. At 205 East Houston St.

Guss' Pickles was featured in the film *Crossing Delancey*. The store sells homemade pickles right out of barrels on the sidewalk. At 85 Orchard St.

Economy Candy is the place for sweet treats from floor to ceiling. At 108 Rivington St.

Essex Street Market offers an authentic neighborhood market feel, good things to eat, and vendor-style photo ops—but ask for permission first. On Essex Street between Delancey and Rivington streets.

> Subway: F or V train to Lower East Side–Second Avenue; F train to Delancey Street; J, M, or Z train to Essex Street.

21. Little Italy/Bowery—New Museum for Contemporary Art

You may walk past Little Italy nowadays and not even know it. Sandwiched between SoHo, the Lower East Side, and ever-expanding Chinatown, much of what remains as touristy Little Italy, mostly restaurants, is now centered along Mulberry Street near Broome and Canal streets.

For a traditional Little Italy encounter, pay a visit to the San Gennaro Festival in mid-September for shots of a time-honored religious procession and boisterous street vendors. Don't forget to sample a zeppole pastry.

A fun architectural photo op of note in the neighborhood is the New Museum for Contemporary Art, which appears as if some New York City giant haphazardly placed six boxes one atop the other. You can playfully capture the building head-on when walking west down Prince Street. Late afternoon lighting is best. Inside there are plenty of exhibitions that inspire artistry, and photography without flash is allowed depending on the exhibit. Cameras and photography are also allowed in their seventh floor Sky Room, which offers one of the

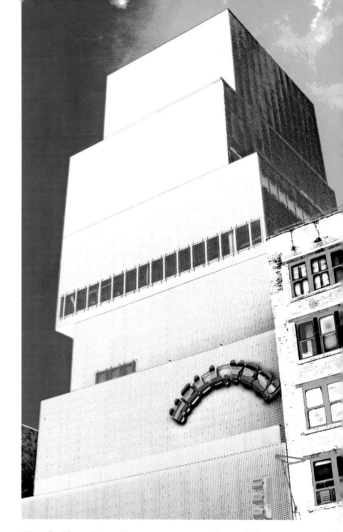

Simple Photoshop adjustments turn a photo of the New Museum for Contemporary Art into a work of contemporary art.

few places in the vicinity that boasts a panoramic view of the neighborhood. The Sky Room is open weekends only. Bulky bags must be checked.

> New Museum for Contemporary Art is at 235 Bowery.
> Subway: 6 train to Spring Street; N or R train to Prince Street; J, M, or Z train to Bowery.
> Admission costs about $12.

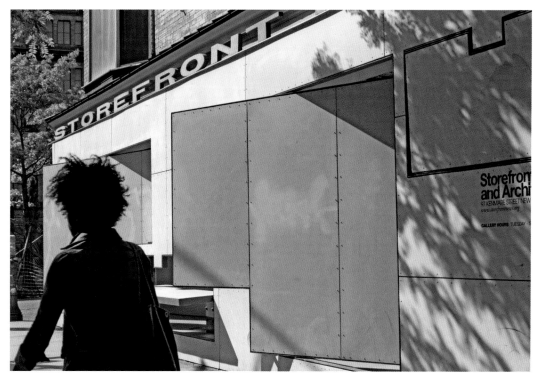

Black and white photography makes a bold statement at the Storefront for Art and Architecture.

Call 212-219-1222.
Visit www.newmuseum.org.

22. SoHo—Storefront for Art and Architecture

Intrepid shoppers, bustling Broadway, and American original cast-iron architecture rule on the streets of SoHo.

SoHo (South of Houston) hugs Little Italy and the Lower East Side to the east, China-town and TriBeCa to the south, and Green-wich Village to the north.

To capture a street corner symphony full of fearless pedestrians and endless taxis cabs, make your way to Broadway—it's as busy as can be in this part of town. You'll also find an abundance of the original American architec-tural design of cast-iron buildings and facades in the preserved SoHo Cast Iron Historic Dis-trict, which is bordered by West Broadway, Houston, Canal, and Crosby streets. These structures number in the hundreds and were constructed in the mid- to late-1800s.

Another popular photo op is the Storefront for Art and Architecture, a small design exhi-bition space that inspires artists, designers, ar-chitects, and photographers both inside and out. And it's just that—a small storefront at 97 Kenmare St. at the corner of Cleveland Place (212-431-5795, www.storefrontnews.org). The exterior boasts few proper windows or doors, but rather minimalist playful cutouts that open and close. I met no fewer than three fellow photographers one afternoon wishing to capture their own unique slice of the Store-front.

You can take photos inside—but it does present interior/exterior lighting challenges.

Inside, wait for a bright yellow cab to fill up a cutout "window" frame. Outside on the sidewalk add the striking silhouette of a passerby in the Storefront foreground shot. The sun peaks in mid- to late afternoon but the line of trees directly in front will create challenges of light and shadow. Wait until dusk to find the place all aglow from the inside out.

Subway: 6 train to Spring Street; R or W train to Prince Street.

23. Greenwich Village—Washington Square Park

Greenwich Village enjoys a storied history of beatniks, bohemians, boisterous buskers, and steadfast intellectuals from decades past to the present—the area is home to some very colorful characters, as well as 50,000 or so students who attend New York University.

The recently renovated Washington Square Park and its often-photographed arch are prominent photo ops. The view of the arch from Fifth Avenue facing south once perfectly framed the World Trade Center. Now the new modern Kimmel Center for University Life building of NYU fills the center arch canvas. A morning shot works best. If you are photographing the arch from this location, turn left to find the row of historical houses known as the Washington Mews as well as the art deco apartment building One Fifth Avenue.

In addition to any number of NYU buildings that offer photographic inspiration in the neighborhood, the Jefferson Market Library, a branch of the New York Public Library, offers gothic revival stylings complete with a circular brick clock tower at 425 Avenue of the Americas near West 10th Street.

The arch in Washington Square Park

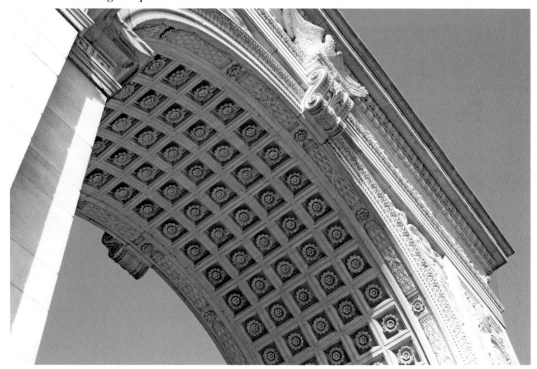

The Meatpacking District

Subway: A, B, C, D, E, F, or V train to West 4th Street (for nearby access to Washington Square Park).

24. West Village—Hudson River Park

Traditionally home to a number of gay bars along Christopher Street, the West Village features a number of worthy shots including vintage storefronts, well-worn signs, and traditional townhouses along Bethune Street just north of Christopher Street, and Barrow and Commerce streets to the south. Be prepared to get lost; this concentration of streets is one of the most confusing in town.

Continue west along Christopher Street to West Street to find a new waterfront park complete with Hudson River views (the park is actually part of the Hudson River Park, which extends from 59th Street to Battery Park). The West Village portion adds a pier and sunbathers to the mix. The adjoining bike path adds in-line skaters and cyclists to the frame. And guess what: New Jersey's got a skyline, too!

The nearby Cowgirl restaurant offers delectable Tex-Mex in a casual setting. My favorite thing to do is order all side dishes and share—pulled pork, mac and cheese, collard greens, and cornbread. At 519 Hudson St. (212-633-1133, www.cowgirlnyc.com).

Subway: 1 train to Christopher Street-Sheridan Square.

25. Meatpacking District—High Line

With its snazzy boutiques, fine array of restaurants, and a hint of grit, what's not to love about the Meatpacking District?

Venturing north from the West Village will lead to the famed Meatpacking District, also known as the Gansevoort Market Historic District. The area, once the prime meat processing commercial hub of the city, now shares space with dozens of restaurants (most along Gansevoort, 12th, 13th, and 15th streets); nightclubs—it's home to the famed Hogs and Heifers, complete with its bar full of celebrity bras; and high-end designer boutiques (most on Washington and West 14th streets). Stella McCartney, Alexander McQueen, and Diane Von Furstenberg have retail digs here—just be careful of corporate logos cropping into the picture.

Along the northern border of the 20-square-block neighborhood you'll find good things to eat and food-themed photo ops at Chelsea Market (75 Ninth Ave. at West 15th Street).

It's also a good time to mention the High Line, the once-abandoned now-renovated elevated train track that runs near Tenth Avenue through the Meatpacking District, West Chelsea, and Hell's Kitchen. A portion of the High Line recently opened to the public and now provides a 1½-mile promenade for relaxing strolls and original views. Visit www.thehighline.org.

While the area is a fun place to play with the camera by day, don't flaunt it at night.

Subway: A, C, or E train to Eighth Avenue-14th Street.

26. Chelsea—IAC Building

There's plenty to keep you busy when photographing Chelsea.

First and foremost, when the name of architect Frank Gehry is mentioned, you know you're in for a photographic treat. At Eleventh Avenue between 18th and 19th streets you'll find Gehry's glass abstract iceberg, the IAC Building, which opened in 2007. You'll have fun playing with this shot. In the afternoon you have the sun at your back, and there's plenty of room to set up a tripod in front of Chelsea Piers across the street. Then come back at dusk

The IAC Building in Chelsea

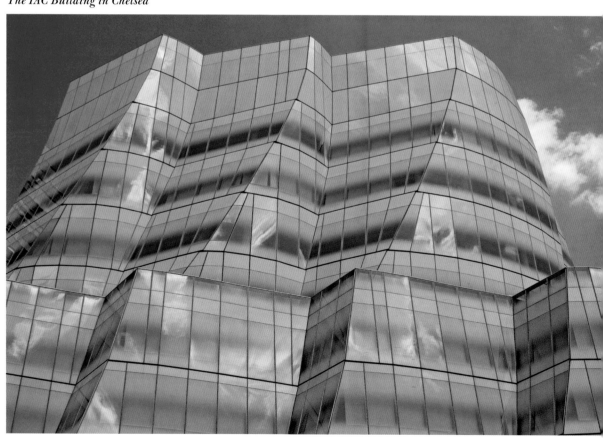

to find the building all aglow. For a photographer, it doesn't get any better than this. Thanks, Frank!

The IAC Building is located across from Chelsea Piers, once the city's main shipping terminal. The terminal would have been the docking point for the *Titanic*. The last remnant of the Cunard and White Star Lines' presence is the rusted metal archway located at Pier 54. Today, Chelsea Piers offers a television studio and extensive sport complex. The area offers great views of the Empire State Building, which are best during afternoon and evening.

Clothing retailer Comme des Garcons adds a futuristic aluminum tunnel for an entranceway at 520 West 22nd St.

The iconic Empire Diner offers a retro stainless steel art deco feel and a generous burger platter at 210 Tenth Ave. between 22nd and 23rd streets.

Another area icon, the Chelsea Hotel, offers a bit of rock 'n' roll history—Janis Joplin, Bob Dylan, and Jimi Hendrix were all guests. And it's where Arthur C. Clarke wrote *2001: A Space Odyssey* says their Web site. The landmark building is best photographed mornings or evenings as the midday sun peaks directly overhead as you face south. At 222 West 23rd St. between Seventh and Eighth avenues.

You'll also see more of the High Line (mentioned previously) snaking along just west of Tenth Avenue. As mentioned before, don't flaunt the camera at night.

> Subway: C, E, or 1 train to their respective 23rd Street station.

27. Union Square Park

Union Square Park, in the Gramercy part of town, is sure to leave you somewhat photographically inspired and slightly bewildered at the same time. This slice of city life provides some of the most colorful characters you'll meet in all of New York City.

Photo themes include colorful artisans selling their wares, boisterous buskers, a plethora of street corners, views of the Empire State Building, and a fine statue of George Washington on horseback (but poor George, I don't think anyone pays him any attention).

A word of warning: Keep an eye on your gear here.

> Union Square Park is bordered by 14th and 17th streets and Union Square East and West.
> Subway: L, N, Q, R, or W train to 14th Street.

28. Flatiron District—Flatiron Building

The iconic Flatiron Building (175 Fifth Ave.) takes front and center frame when photographing the Flatiron District. You'll spend half the day on this subject alone.

Built in 1902, the distinctive triangular

A painter in Union Square Park, shot at 1/60, f 4.5, ISO 400

building was made to fill the available plot of land. Famed photographer Alfred Stieglitz called the building "unnerving" to photograph.

While the landmark building has been captured on film many times before, there are ways to make it your own. Try adding a foreground lamppost, the sliver of a crescent moon, a passing plane high in the sky, or a shadow cast by a nearby building. Slightly tilt the camera to create a playful abstract. But most of all shoot the building from the front to capture its distinctive triangular shape.

You face south when standing in front of the Flatiron Building, so the sun will peak overhead midday. The ample plaza across the street to the north (next to Madison Square Park) offers modern urban polish to the foreground.

The mightiest of metropolitan barbeques for lunch or dinner can be sampled at RUB, Righteous Urban Barbeque at 208 West 23rd Street between Seventh and Eighth avenues (212-524-4300, www.rubbbq.net).

Subway: R or W train to 23rd Street.

29. Midtown South Central — Madison Square Park

Madison Square Park provides a good vantage point from which to capture the Flatiron Building due southwest and provides foreground space to shoot a number of beautiful skyscrapers in the opposite direction.

Along the park's Madison Avenue border you'll find the Metropolitan Life Insurance Company Building (1 Madison Ave.), and the New York Life Building (51 Madison Ave.) with its distinctive gold peak. In winter, the park's bare tree limbs provide an eclectic abstract foreground to the skyscrapers shot. Morning shots work best for the Flatiron Building while afternoon shots work best for the rest.

Then face north when standing to the west side of the park along Fifth Avenue near East 26th Street and you'll get a great shot of the

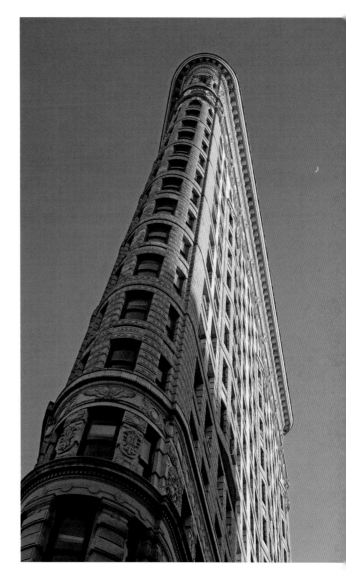

The Flatiron Building

Empire State Building seven blocks away. Again, late afternoons leave the sun at your back.

For informal but good sold-by-the-pound buffet-style eats with dozens of hot and cold options try Café 28 Gourmet Deli (245 Fifth Ave., 212-686-7300).

Subway: R or W train to 23rd Street.

The Empire State Building

III. Midtown Manhattan

General Description: Midtown Manhattan is basically tourist central—look no further than the Empire State Building, Times Square, Rockefeller Center, and the theater district. But lots of locals work and play here as well. And with Manhattan's grid system of streets now present, the most lost you'll get is only by a city block—or two. The suggestions continue from south to north, but meander from west to east and back. Adjust your itinerary accordingly.

Directions: There are dozens of subway stops in the area, including major transfer hubs at Penn Station-34th Street, Times Square, Grand Central, and 42nd Street stations. What's mentioned with each entry gets you close; check the subway map for more options. Midtown's also a good place to venture on a New York City bus.

30. Empire State Building

There's a scene in *Sleepless in Seattle,* starring Tom Hanks and Meg Ryan, where Ryan's character fulfills a fantasy meeting with her soul mate (Hanks), at the top of the Empire State Building, on the observation deck. In the movie, the scene plays out in mere minutes with the actress rushing from the taxicab to finagling her way past the security guard (I don't even think she paid the admission fee), to bypassing any lines. Ah, Hollywood magic. Lines? What lines?

The truth is you could probably watch the entire movie in the time it takes you to purchase your tickets, wait for not one but two elevators, walk about the observatory with a few hundred of your closest tourist friends, and wait again for two elevators to get you back down to earth.

I hadn't been to the observation deck in years and waited 35 minutes during a late

Where: from above 34th Street to Central Park South (59th Street); from the Hudson River to the East River

Noted for: commuters, bright lights, a little song and dance, seeing forever (clear days and nights apply) and strained necks—look at those buildings!

Exertion: minimal (for a lot of walking on level terrain)

Parking: Again, it's Manhattan. Opt for public transportation or walk.

Sleeps and Eats: The mod Millennium Hotel will leave you in the middle of Times Square. There are dozens, if not hundreds, of hotels and restaurants located in this tourist part of town.

Public Restrooms: available at Penn Station, Times Square Info Center, Grand Central Terminal

Sites Included: The Empire State Building, Times Square, Intrepid Sea Air Space Museum, Chrysler Building, United Nations

Area Tips: Allow extra time for visits at New York City's iconic sightseeing spots.

March evening visit. On its busiest days the observation deck accommodates some 20,000 visitors. Expect to wait at least two hours on those days just to get to the top of the building, and another 20 minutes or more to get back down.

Besides the wait, also be prepared for pushy salespersons along Fifth Avenue, the $20 admission fee, airport-style security screening, and a small crowd on the deck, which leaves little room for a tripod.

All that said—LOOK AT THAT VIEW— that is the magnificent New York City metropolitan area from the tallest point in town at

your photographic whim! Dusk is a great time to visit and photograph. A zoom lens helps. Again, just allow extra time. If taking a shot of the Empire State from the street, the building's Web site offers the Tower Lights theme-colors lighting schedule for any number of special lighting displays. For example, on and around Labor Day, you bet it's red, white, and blue.

> The Empire State Building is at 350 Fifth Ave. between 33rd and 34th streets.
> Subway: 1, 2, 3, A, C, or E to Penn Station-34th Street.
> Admission costs about $20 or use your CityPass (see Practical New York City Travel Info in the back of the book).

Call 212-736-3100.
Visit www.esbnyc.com.

31. Farley Post Office Building

The Farley Post Office Building is the city block–long main mail-processing center in Manhattan. It's located directly across from Penn Station and Madison Square Garden. You can play with perspective here as some two dozen majestic columns and a grand staircase fill the entire frame. The columns and stairs can be captured facing north or south. Silhouettes of post office clientele ascending or descending the stairs add perspective of size to the shot.

Two blocks to the north you'll find some

The view from the Empire State Building observatory

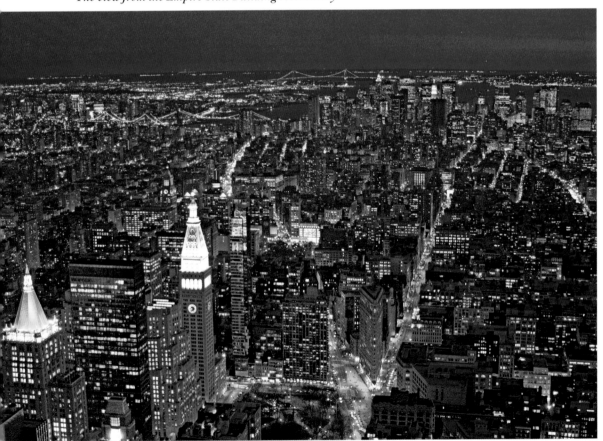

opulent digs at the New Yorker Hotel, a midtown art deco gem at 481 Eighth Avenue and 34th Street.

Walk around the block to the northeast corner of Penn Station along 33rd Street looking east to get another fine view of the Empire State Building.

And not to plug any particular camera supply store, but B&H is the granddaddy of them all at 420 Ninth Avenue between West 33rd and 34th streets.

> Farley Building is at Eighth Ave. between West 31st and West 33rd streets.
> Subway: 1, 2, 3, A, C, or E train to Penn Station-34th Street.

32. Intrepid Sea, Air & Space Museum

The *Intrepid,* a retired WWII aircraft carrier built in 1943, adds military might to the photo mix. The ship has been docked along the Hudson River Pier since 1982 and recently received an extensive makeover. A number of jet fighter aircraft and the *Growler* submarine provide additional photo ops.

If you just want a quick shot without interior ship entry, photos can be captured from along Twelfth Avenue and the neighboring pier. Add authentic sailors and military seafaring vessels to the frame during New York City's Fleet Week every mid-May.

> Intrepid Sea, Air & Space Museum is at Pier 86, Twelfth Avenue and 46th Street.
> Subway: A, C, or E to 42nd Street-Port Authority; walk four blocks west.
> Admission costs about $20 for adults; free for active or retired military.
> Call 212-245-0072.
> Visit www.intrepidmuseum.org.

33. Hotels of Note

The Westin Hotel provides a geometric abstract grid of colored windows to the frame. At 43rd Street and Eighth Avenue.

The Westin Hotel, shot at 1/125, f 7.1, ISO 100

Clean lines and busy Park Avenue perspective can be captured at the Waldorf Astoria. At 301 Park Ave. between East 49th and East 50th streets.

Take a black and white photograph of a horse drawn carriage along Central Park South in front of the Plaza Hotel for a real vintage feel. At Fifth Avenue and 59th Street.

34. Broadway Theaters of Note

Fans of David Letterman can make their way to the Ed Sullivan Theater for a shot of the famous *Late Show* marquee, which adds neon punch to a busy Broadway street scene. At 1697 Broadway between West 53rd and West 54th streets.

Intricate ornate architectural details ooze all over the Lyric Theater façade, now the Hilton Theatre at 214 West 43rd St. between Seventh and Eighth avenues.

You haven't quite hit the big time unless you've played Carnegie Hall, which offers an understated Italian renaissance sensibility.

In the early 1980s or so during a concert trip

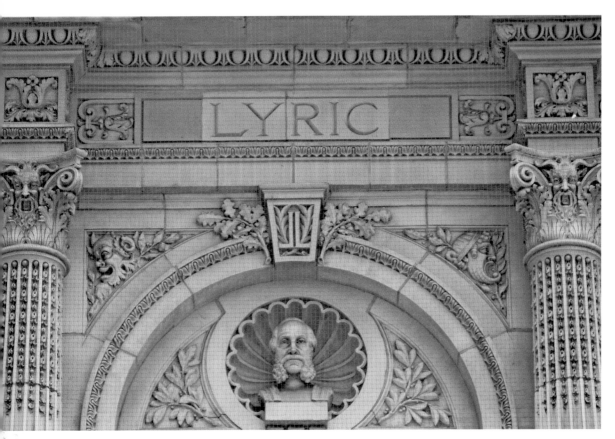

The Lyric Theatre

with some friends to Carnegie Hall—and as a young visitor from the Long Island suburbs—I was nominated to ask the subway token clerk for directions.

"How do I get to Carnegie Hall," I asked.

Do you see where this is going? C'mon, I was only 18! He must have waited years to reply . . . "Practice."

He didn't blink an eye.

True story.

Carnegie Hall is at the corner of West 57th St. and Seventh Ave.

35. Times Square

With flashing marquees, bright lights, and bustling tourists, Times Square offers sensory overload to any shot any time of day or night. This is undoubtedly the place that earned NYC the moniker "the city that never sleeps."

New in 2009, the area was transformed into a pedestrian-only zone—so now iconic bright yellow New York City taxis will be missing from your shot.

For a bird's-eye view and shot, the Marriott Marquis Hotel (1535 Broadway, 212-704-8740) offers two eighth-floor lounges that overlook Times Square. That said, you'll have to buy a beverage and you'll be shooting through glass. Instead, take a shot of the Marriott's amazing interior, which is basically all atrium except for a bank of elevators and a circular revolving restaurant (The View) on the

47th floor. The scene resembles a sci-fi movie set and offers a fun play on perspective.

At Seventh Avenue and Broadway, mostly between 42nd and 47th streets.
Subway: 1, 2, 3, 7, N, Q, R, or W train to Times Square-42nd Street.

36. International Center for Photography

Put the camera away, take a well-deserved break, and be prepared to be photographically inspired. Here's a place you can call your own.

The International Center for Photography, the ICP, is New York City's premier place with the photographer and photography in mind. The ICP features museum space offering top-notch exhibitions, a school that offers work-shops (some that travel throughout the U.S.), lectures, special events, a library, a fine museum gift store, a knowledgeable staff, and tips for beginners to pros—all the resources a photographer needs. A visit does not disappoint.

In its cozy but modern museum space, the ICP has paid tribute to the likes of Richard Avedon, Henri-Cartier Bresson, and Robert Capa. Fashion, travel, and news photography all get proper due. Thematic exhibitions are also presented by subject and photographic technique and have included everything from historic figures to trick photography, seascapes to a display of works by student photographers. The building is appropriately located in the New York City offices of Kodak.

Times Square, shot at 1/30, f 5.6, ISO 320

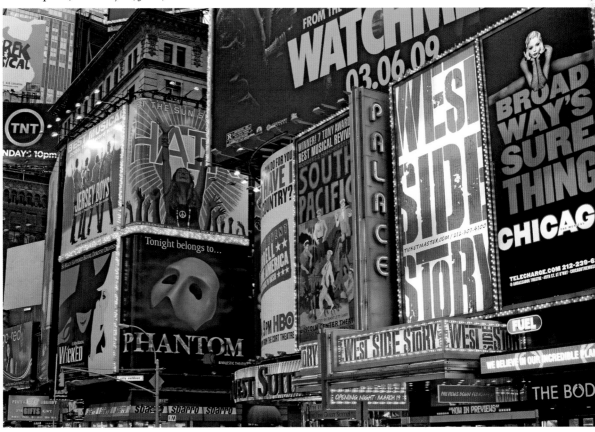

Now get out there and take some photographs!

International Center for Photography is at 1133 Avenue of the Americas at 43rd Street.
Subway: 1, 2, or 3 train to Times Square.
Admission costs about $12 for adults. Closed Mondays.
Call 212-857-0000.
Visit www.icp.org.

37. New York Public Library

Although there are many satellite branches, the Stephen A. Schwarzman Building of the New York Public Library system is known as the main branch—this is the grand Beaux Arts building flanked by two proud lion sculptures dubbed (from south to north) Patience and Fortitude by Mayor Fiorello LaGuardia in the 1930s, says the Web site. These two indeed make a patient pair of models: They always sit still, never complain, and work for free (although a donation to this or your own library is always appreciated). Morning shots are best when capturing the Fifth Avenue façade. Shots from the rear near Bryant Park can also squeeze in the Chrysler Building to the east and the Empire State Building to the south.

Interior photography is allowed; a quick bag search is done upon entry. While flash is not permitted, a number of architectural elements such as marble archways, magnificent murals, and intricate wood carvings are worth a close-up, although the color of the marble is tricky to capture just right with the lighting that's present. The main reading room offers rows of chandeliers, desk lamps, and steadfast readers to the frame, which creates a fun shot of perspective.

The New York Public Library

The library's bookstore offers a well-stocked variety of New York City–themed photography books and is worth browsing. Guided tours are held daily.

Sample a delicious slice of New York around the corner at Bravo Pizza (6 East 42nd St.).

New York Public Library is at Fifth Avenue and 42nd Street.
Subway: 1, 2, or 3 train to Times Square-42nd Street.

38. Grand Central Terminal/ Pan Am Building

Welcome to the never-ending commuter ballet known as Grand Central Terminal.

Inside, the place percolates with rushing passengers. Here, have some fun with your camera's automatic sports setting to freeze the frame or cleverly capture motion and blur. The backdrop of vintage wickets, a centerpiece information kiosk, and two grand staircases set the scene. At either staircase you'll undoubtedly find many tourists photographing the masses. A balcony perspective adds an elevated view to your shot. And ceiling details subtly convey the twelve zodiac constellations and the stars of many American flags.

Exterior shots in the immediate vicinity offer mirrored glass façades, soaring statues, an ornate overpass, the central clock, and a perspective shot of the Pan Am Building along Park Avenue.

At Park Avenue and East 42nd Street.
Subway: 4, 5, or 6 train to Grand Central-42nd Street.

39. Chrysler Building

Ask many a New Yorker what their favorite building is, and the Chrysler Building usually tops the list—and rightly so.

The Chrysler Building defines plush art deco splendor, complete with a gleaming steel

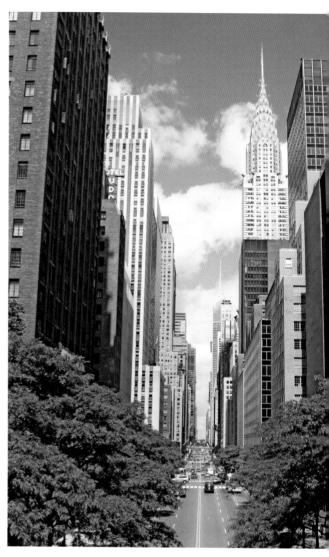

With its magnificent spire, the Chrysler Building is a midtown Manhattan standout.

crown that peaks to perfection, magnificent eagle gargoyles that stand an all-corners guard, and triangle-shaped windows that create a radiating sunburst of beauty.

Constructed from 1928 to 1930, at 77 stories tall the Chrysler Building was the tallest building of its day, but for just a short clip—the Empire State Building took the top spot less

Fire and ice: Prometheus oversees the Zamboni's work at the Rockefeller Center skating rink.

than one year later. With the World Trade Center gone, the Chrysler is now the second tallest building in the city.

A bird's-eye view can be had with a zoom lens from the Empire State Observatory or from Top of the Rock, the Rockefeller Center observatory. Also incorporate the building in a unique vertical shot of skyline perspective of 42nd Street facing west from the Tudor City Place overpass near First Avenue.

> Chrysler Building is at 405 Lexington
> Avenue at 42nd Street.
> Subway: 7 train to Grand Central Station.

40. United Nations Headquarters

International intrigue can be captured at the United Nations Headquarters complex, which consists of four main buildings; the more pho-tographed sweeping General Assembly building and the 39-story Secretariat building. Rows of flags of all nations add colorful perspective throughout. A sculpture of note displayed on the grounds is *Non-Violence* designed by artist Carl Fredrik Reuterswärd, which depicts a gun with its barrel tied in a knot.

A row of trees adds foreground green to the shot along First Avenue but block the General Assembly Building in summer. Make your way to the rear, or better yet capture the space from the East River aboard a boat such as the Circle Line. Shots from a short distance can also be had from Roosevelt Island (see entry 46).

> United Nations is at First Avenue between
> 42nd and 48th streets.
> Subway: 7 train to Grand Central Station;
> walk four blocks east.

41. Rockefeller Center/Radio City Music Hall

You can set your calendar by the the ever-changing seasonal displays at the Rockefeller Center tourist/media mecca. Winter provides a rink and skaters, a famous Christmas tree, and a red zamboni sweeping past a golden Prometheus. Rows of flags of all nations and masterpiece art deco architectural details offer colorful explorations all year long.

Midtown skyline views can be captured from the GE Building's Top of the Rock observation deck, a newcomer to the New York City observatories scene since 2004. It's not as busy or as tall as the Empire State Building (70th floor vs. the 86th floor) but it's pretty spectacular and you get to include the Empire State Building in your shot.

Across the street, Radio City Music Hall offers a nostalgic marquee shot. The long, *lonnng* line of the Rockettes provides great perspective, but photos aren't allowed in the theater. Juxtapose the art deco GE Building with the two eminent domain holdouts at the corners of Avenue of the Americas and 50th and 49th streets, respectively. The two buildings were former Irish pubs, the owners of which wouldn't sell to Mr. Rockefeller at any price. You can't miss them if you look for them.

> Rockefeller Center encompasses from West 48th to 51st streets between Fifth and Sixth avenues. Top of the Rock and skating rink access is at 30 Rockefeller Plaza between West 50th and West 51st streets.
> Subway: B, D, F or V train to 47th–50th streets-Rockefeller Center.
> Top of the Rock Observatory visit costs about $20.
> Call 212-698-2000.
> Visit www.rockefellercenter.com or www.topoftherocknyc.com.

42. St. Patrick's Cathedral

The magnificent Rockefeller Center bronze sculpture *Atlas* commands attention at 630 Fifth Avenue. The shot facing *Atlas* is a very good one, and I spent a short while trying to capture it just right.

Watching me watching *Atlas* was an amiable older gentleman—I'm guessing a seasoned New

St. Patrick's Cathedral with Atlas, *shot at 1/30, f 5.6, ISO100*

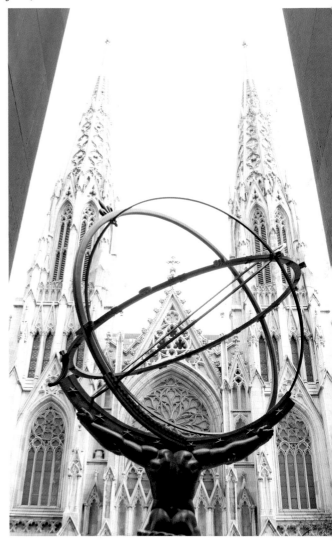

Yorker—walking south along Fifth Avenue. Not missing a step, he approached.

"This is your shot," he said waving his hand—this photo op detour more important than his own destination. The man walked toward the back of the *Atlas* sculpture.

"Look," he pointed up. You can't do anything but.

And there was *Atlas* balancing the weight of the world adorned with the magnificent spires

American Folk Art Museum

of St. Patrick's Cathedral, a Neo-Gothic breath-taker in the background. It takes you a minute, the scene is so lovely. It's a wonderful shot. And it works in any weather condition.

I didn't even have time to thank the gentleman before he disappeared somewhere along Fifth Avenue. To you, sir, a good day. And thanks for the simple photographic reminder we sometimes forget: Scope out your subject from all angles.

St. Patrick's Cathedral dates from 1858 to 1878 (construction was halted during the Civil War). The interior is equally ornate. Admission is free but attendants will scoot you to the side pews when a wedding takes place.

St. Patrick's Cathedral is at Fifth Avenue between 50th and 51st streets.
Subway: B, D, F, or V train to 47th–50th streets-Rockefeller Center.
Call 212-753-2261.
Visit www.saintpatrickscathedral.org.

43. American Folk Art Museum

The oh-so-modern monolithic design of the American Folk Art Museum is juxtaposed with the centuries-old art treasures found inside. The space inspires throughout.

While the museum dates to 1961, this new building opened in 2001. The 85-foot-tall front exterior is composed of 63 panels made of tombasil, a white bronze alloy, says their Web site. The design, meant to evoke the human hand, subtly catches existing light throughout the day in a variety of deceptively playful ways.

American Folk Art Museum is at 45 West 53rd Street.
Subway: E or V train to Fifth Avenue-53rd Street.
Admission costs about $9 for adults.
Call 212-265-1040.
Visit www.folkartmuseum.org.

44. Museum of Modern Art

Oh MoMA!

The Museum of Modern Art is the place for playful, imaginative, artistic inspiration in the form of contemporary paintings, sculpture, prints, media, and special exhibitions. Fans of Kandinsky, Mondrian, modern art, magical multimedia, eclectic installations, viral videos, daring design, and fantastic film and photography to the front of the line.

You can take photos inside of the permanent galleries for personal use but no flash or tripods are allowed. Permission from the museum is required for photographs that are to be reproduced, distributed, or sold. All backpacks must be checked.

> MoMA is at 11 West 53rd St.
> Admission costs about $20 for adults; free for all Friday from 4 to 8 PM (now that's what I call Happy Hour!); or use your CityPass.
> Subway: E or V train to Fifth Avenue-53rd Street.
> Call 212-708-9400.
> Visit www.moma.org.

45. Citigroup Center

Formerly the Citicorp Center, it's best to capture Citigroup Center's most prominent attribute—its slanted slice of a rooftop—from a short distance away. Or if you're brave enough and the lighting and weather cooperates, stand in the middle of 53rd Street, look up, and snap away for a fun shot of steel and sky (bring a friend to warn for traffic). Across the street from Citigroup Center, the Lipstick Building offers calming curves in a canyon of rigid corners. At 885 Third Ave. between East 53rd and East 54th streets. Capture both reflected in glass in a fun shot of the façade of 875 Third Ave. across the street.

Just north of the Lipstick, the simple U.S.

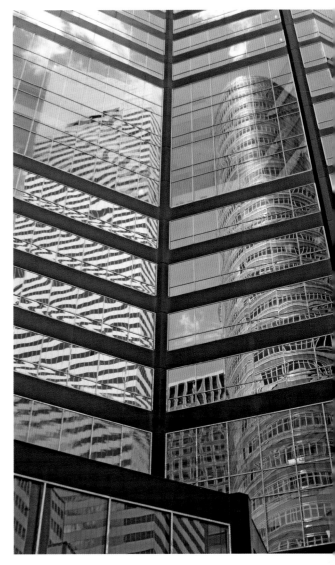

A different perspective on the Citigroup Building. The Lipstick Building is reflected in its windows.

Post Office building adds a juxtaposed sea of geometric squares that when shot close-up at wide angle go on forever.

> Citigroup Center is at 153 East 53rd Street and Lexington Avenue.
> Subway: E train to Lexington Avenue-53rd Street.

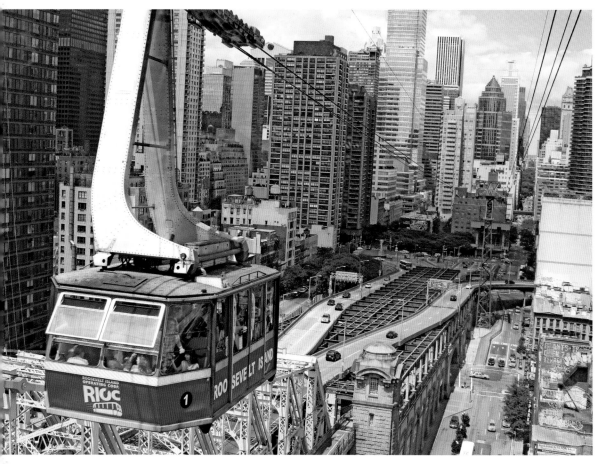

The Roosevelt Island Tramway, shot at 1/200 f 9.0, ISO100

46. Roosevelt Island Tramway

The Roosevelt Island Tram has been transporting commuters from residential Roosevelt Island to Midtown since 1976. It also provides some fine views of Manhattan, but you'll need to be quick with the camera—the ride lasts about four minutes. Even though you're shooting through thick glass, you can still get some fun clear shots. Back on solid ground, add the tram to the foreground of your Manhattan skyline shot. Also opt for a tour around Roosevelt Island proper aboard the red minibus, which will set you back a whopping 25 cents. The island also features a few historical buildings and a waterside promenade steps from the tram station.

> Roosevelt Island Tramway is at 59th Street and Second Avenue.
> Subway: 59th Street-Lexington Avenue.
> One-way admission costs an adult subway fare.
> Call 212-832-4543, ext. 1.
> Visit www.rioc.com.

47. Modern Skyscrapers of Note

The new New York Times building, which opened in 2007, offers 52 floors of glass and steel, and in 2008 two intrepid climbers scaled

the slat-sided façade—on the same day. At Eighth Avenue between 40th and 41st streets.

The Hearst Tower, which opened in 2006, offers a geometric glass and metal crisscross façade worthy of exploring. At Eighth Avenue and West 57th Street.

The new glass digs of the Museum of Arts & Design replaced the minimalist concrete stylings of its predecessor in 2008. The result was not without some local architectural controversy. At 2 Columbus Circle.

48. Columbus Circle/Time Warner Center

How do you make an entire building disappear? Venture to Columbus Circle to capture the all-glass façade of the Time Warner Center, which reflects everything from a bright blue sky to a kingdom of clouds. Get there in the morning for the sun to be at your back. The statue of Columbus adds a foreground silhouette to the shot while the circle itself creates a hodgepodge of modern yellow cabs mixed with vintage horse-drawn carriages—in other words: New York City traffic! And lots of it.

Venture inside to capture the Columbus Circle view from the second floor mall balcony. A bird's-eye view is available at the 35th floor lobby/lounge of the Mandarin Hotel (60th Street entrance), but you will have to buy a beverage if you want a window seat.

At Columbus Circle and 59th Street.
Subway: 1, A, B, C, or D train to 59th
 Street-Columbus Circle.

Columbus Circle

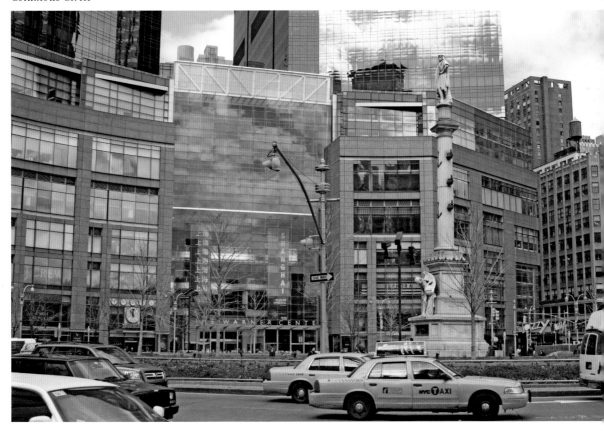

IV. Uptown Manhattan—Central Park, Upper East Side, Upper West Side

General Description: This final chapter on Manhattan covers the most ground geographically—about 65 blocks from south to north—and then some. The entries become more spaced apart from each other than the previous Manhattan chapters, so be prepared for even more walking than you've already done.

Directions: The Lexington Avenue express (4 or 5 train), and the local (6 train), gets you to points on the Upper East Side. The 7th Avenue express (7 train), and local, the 1 train, gets you to Upper West Side stops. The A, B, C and D run along Central Park West as well.

49. Central Park (South)

Central Park is New York City's living, breathing green gem—a tranquil respite for some hurried urban souls. It was designed by Frederick Law Olmsted and Calvert Vaux and opened in 1859. These next three entries divide the 843-acre Central Park into three geographic areas and include photo ops you'll find within each. You could spend the day and probably will.

While the park does get its equal share of locals and tourists, if you venture out in the early morning hours, you can really call the park your own and capture some magnificent lighting (the park is officially open from 6:00 AM to 1:00 AM). Central Park Conservancy offers a dozen specialized one-hour volunteer-led tours year-round.

A number of well-known photo ops lay claim to the more southern reaches of the park. Here you'll find the Wolman Rink, the Central Park Zoo, the Carousel, a New York City bargain at $1.50 a ride, and the magnificent Mall,

Where: the remainder of Manhattan from Central Park South (59th Street) and above

Noted for: urban greenery and unexpected scenery, clean lines, grand houses of worship, natural history, Museum Mile

Exertion: minimal–moderate for walking

Parking: Surprisingly, I find the Upper East Side and West Side just slightly easier to find parking in than other parts of town (did I say that out loud?).

Eats: Harlem home cooking (see entry 63)

Public Restrooms: at all of the museums mentioned in the chapter

Sites Included: Central Park, Guggenheim Museum, American Museum of Natural History, Grant's Tomb, Cathedral Church of St. John the Divine

Area Tips: Pace yourself. That said, you're never far away from a well-deserved break in Central Park. And since Central Park defines New York City in its own unique ways, the space gets three entries all its own.

a grand promenade of park benches and shade trees that runs from 66th Street to 72nd Street.

From 59th Street to Terrace Drive/72nd Street.
Subway: West Side—1, A, B, C, D train to 59th Street-Columbus Circle. East Side—N, R, or W train to Fifth Avenue.
Central Park Conservancy (tour schedules) 212-360-2726.
Zoo admission costs about $10 for adults. For zoo info call 212-439-6500.
Visit www.centralpark.org.

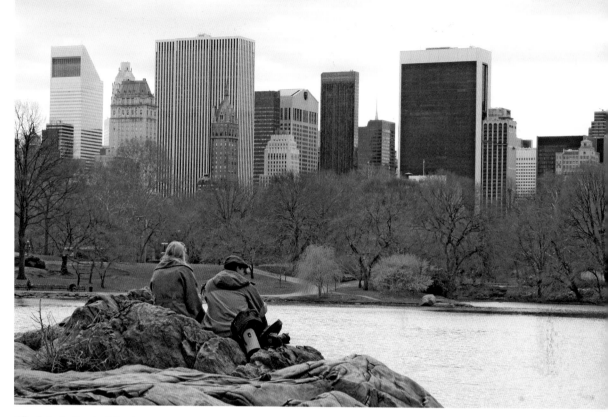

The lake in Central Park

50. Central Park (Central)

Continuing along the Mall to mid-park will lead to Bethesda Fountain and Terrace, a picturesque place for people-watching. Bethesda Terrace overlooks the Central Park Lake, which adds rowboaters to the frame from 71st to 78th streets

The Ramble offers a relaxing stroll of flora and woodlands complete with pathways and archways from 73rd to 79th streets. Belvedere Castle at 79th Street offers a bird's-eye panoramic view of Turtle Pond and is its own photo op.

On the West Side, Strawberry Fields offers a landscaped garden space in honor of the late John Lennon between 71st and 74th streets. Rent your own rowboat for a unique perspective of water and skyline at the Loeb Boathouse between 74th and 75th streets on the east side. Rentals cost is about $12 for the first hour.

> From Terrace Drive/72nd Street to the 86th Street Transverse Road.
> Subway: West Side—B or C train to 81st Street-Museum of Natural History. East Side—6 train to 77th Street.

51. Central Park (North)

With tranquil trails, rambling woods, and meandering streams, the northern reaches of Central Park definitely have a more remote feel. Here, you will truly feel as if you are far away from the confines of a concrete city.

Photo ops include the well-manicured Conservatory Garden that offers French, Italian,

and English garden inspiration on the east side at 105th St. The Harlem Meer is the second largest body of water in the park, from 106th Street to 110th Street.

> From the 86th Street Transverse Road to 110th Street.
> Subway: West Side—B or C train to 96th Street. East Side—4, 5, or 6 train to 86th Street.

52. Lincoln Center for the Performing Arts

Among its impressive list of performing arts companies, Lincoln Center is home to the New York Philharmonic, New York City Opera, New York City Ballet, and a dozen theaters.

While photos aren't allowed of the indoor performances, exterior photographic inspiration comes in the form of a completely renovated main plaza, bustling patrons, the centerpiece Revson Fountain, and hundreds of swing dancers who shimmy the night away most July evenings at the on-site Damrosch Park's Midsummer Night Swing Fest.

Morning shots leave the sun at your back; shots at dusk with the scene all aglow are better.

> Lincoln Center is at Columbus Avenue between West 62nd and West 66th streets.
> Subway: 1, A, B, C, or D train to 59th Street/Columbus Circle.
> Visit www.lincoln.org.

53. Upper West Side Apartment Buildings: The Dakota, San Remo

The Upper West Side, particularly along Central Park West, boasts some of the toniest addresses in town. Perhaps none comes with

The Dakota

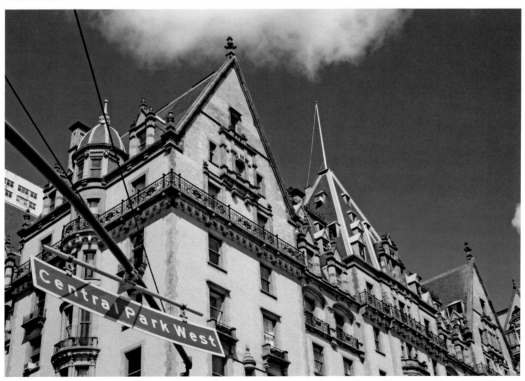

The Whitney Museum of American Art, shot with 1/60, f 4.0; ISO 400

more of a history than the Dakota apartment building, a U.S. National Historic Landmark, which offers a Northern European Renaissance feel and dates to the 1880s. It was commissioned by Edward Clark, head of the Singer Sewing Machine Company.

The Dakota comprises a full city block though no sign announces you're there; it's home to a slew of well-known residents. The late John Lennon was assassinated near a front entrance there in 1980. Even more impressive is the neighboring San Remo Apartments one block north, again a primary or secondary home to many a Hollywood celebrity. You can't miss it as the San Remo's ornate twin towers beckon from blocks away.

Photos of either can be taken from along Central Park West—wait for a bright yellow cab in the foreground to add colorful punch. From inside the park facing west during morning hours when the sun is at your back, add a passing jogger or bicyclist to the foreground. Visit

in spring—mid-April—when the tree buds begin to bloom for a less barren but abstract look.

> The Dakota is at Central Park West at 72nd and 73rd streets.

> The San Remo Apartments are at Central Park West at 74th and 75th streets.
> Subway: B or C train to 81st Street.

54. Whitney Museum of American Art

The Whitney houses two centuries of iconic American art, everything from traditional oil paintings to awesome installations, unpredictable performance art to avant-garde video. Photography also plays an important part in the collection, and inspiring works from the likes of Robert Mapplethorpe, William Egglesten, and Andy Warhol are often highlighted.

While photography is not permitted inside the galleries, you'll still spend plenty of time photographing the exterior, the minimal but bold Breuer Building designed by architect

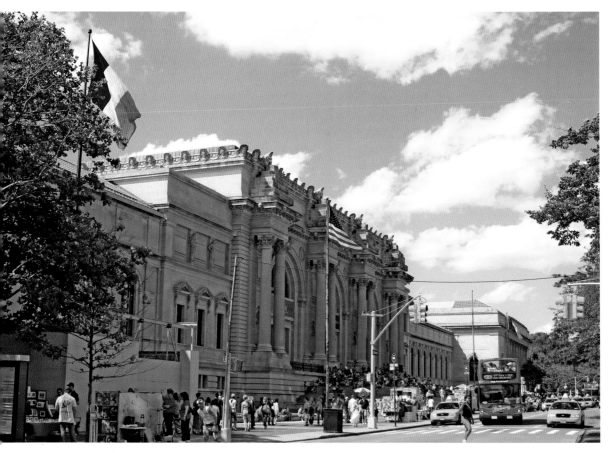

The Metropolitan Museum of Art

Marcel Breuer. The brutalism style, popular from the 1950s to the 1970s, emphasizes concrete in all its architectural glory. The building faces west so the afternoon sun is at your back and right.

Whitney Museum of American Art is at
945 Madison Ave. at 75th Street.
Subway: 6 train to 77th Street.
Admission costs about $15 for adults.
Call 212-570-3600.
Visit www.whitney.org.

55. Metropolitan Museum of Art
The Metropolitan Museum of Art is artistically inspiring inside and out.

The neoclassical stone façade with its sweeping columns makes your heart beat just a bit faster for the wealth of art treasures that await inside. You'll find everything from magical medieval to modern art; iconic American paintings and decorative arts; gorgeous Greek and Roman sculptures and antiquities; and, of course, a daring display of photography from daguerreotypes to modern-day prints. What a wonderful space—you could spend the day.

And there's good news for photographers. Photos of the permanent collection are allowed unless noted. And while flash is prohibited at all times, tripods are allowed Wednesday through Friday with a permit from the infor-

mation desk. That said, the photos must be used for private noncommercial use only.

The Metropolitan Museum of Art is at 1000 Fifth Avenue at 82nd Street.
Subway: 4, 5, or 6 train to 86th Street.
Suggested adult admission costs $20 or use your CityPass.
Call 212-535-7710.
Visit www.metmuseum.org.

56. Guggenheim Museum

We thanked one Frank earlier in the book—it's time to thank another.

The illustrious Guggenheim Museum celebrated its 50th anniversary in 2009. Architect Frank Lloyd Wright indeed designed the building.

While photos are not allowed inside past the lobby, it really doesn't matter as there's enough inspiration from the clean lines, lyrical curves, and calm white bathed against a bright blue sky to keep you busy. It's fun to get up close and go for a minimalist photo abstract. The building creates a new photographic architectural landscape with each step and every turn. You'll spend half the day and still want more. Bring a friend to help as lookout when you need to dodge traffic, as you'll occasionally be standing in the middle of Fifth Avenue. Afternoon shots leave the sun to your right and back.

Guggenheim building images are considered trademarks and need written consent for commercial purposes.

One block north, the Church of the Heavenly Rest is worthy of a shot.

Guggenheim Museum is at 1071 Fifth Avenue at 89th Street.
Subway: 4, 5, or 6 train to 86th Street.
Admission costs about $18 or use your CityPass
Call 212-423-3500.
Visit www.guggenheim.org

57. Cooper-Hewitt, National Design Museum

Venture two blocks north from the Guggenheim to find inspiration in the art of design at the Cooper-Hewitt, National Design Museum, where textiles, toasters, and tape measures get their proper due.

Photos are prohibited inside, so just enjoy and take pointers from the extensive collection of photography and decorative arts that falls under the Smithsonian Institution umbrella. Once outside, snap away. The exterior oozes with Upper East Side elegance—the mansion was once home to Andrew Carnegie.

It's a good time to mention image rights and how museums handle their collections. Most museums require permission for photos to be used commercially. Cooper-Hewitt employs Art Resource, a photo archive outfit, to handle requests for image rights and reproductions. The point here: Check copyright requirements and restrictions at your favorite museum *before*

Exterior detail of the Cooper-Hewitt Museum

you use any interior shots on your Web site or in print.

Cross the street to Central Park to find a fantastic view of the Jacqueline Kennedy Onassis Reservoir, an urban ocean that will fill up your frame.

> At 2 East 91st Street.
> Subway: 4, 5, or 6 train to 86th Street station.
> Adult admission costs $10.
> Call 212-849-8400.
> Visit www.cooperhewitt.org.

58. Gracie Mansion

While City Hall is where New York City's mayor works, historic Gracie Mansion is where the mayor lives (it's optional). It was built in 1799.

The exterior is cordoned off by a fence so you can only photograph the upper floors of the Federalist-style building. There are views of the Hell's Gate part of the East River as well from Carl Schurz Park, the plot of green that surrounds the mansion. Interior tours are available Wednesdays, but photography is not permitted inside. Nonetheless, sumptuous architectural highlights include the blue library, the yellow parlor, a trompe l'oeil painted foyer floor, and a stately summer porch.

It's a bit out of the way, but the area offers abstract building close-ups and fun perspective shots complete with rows of trees and fire escapes. There are plenty of restaurants in the area as well along Second and Third avenues.

> Gracie Mansion is at East End Avenue and 88th Street.
> Subway: 4, 5, or 6 train to 86th Street.
> Call 212-639-9675 for tour info (about $7 for adults).

From here, the Upper East Side, we venture north and west of Central Park to Morningside Heights and Harlem.

59. The Cathedral Church of Saint John the Divine

This is perhaps the most beautiful and one of the more photogenic houses of worship in town.

For sheer size alone, you can't miss it: It is considered to be the fourth largest church in the world (in terms of floor area). A first glance prompts you to catch your breath—guaranteed. It is so immense that the interior runs the length of about two football fields—plenty of time for either party to change their mind if a dose of cold feet strikes on the big wedding day.

The awe-inspiring gothic revival exterior oozes with details such as grand archways, massive doors, and the centerpiece rose window. It's hard to squeeze all that magnificence into the shot even with a wide angle. Opt for architectural detail close-ups. When facing the façade, the sun will be to your right and back in the afternoon. An adjacent small park with the sculpture titled *Peace Fountain* adds another photo op to the visit. Take the time to walk around the entire grounds.

The interior is also worth a peak but entry costs a suggested $5—well worth the price as the structure was severely damaged by fire in 2001. The church reopened to the public in 2008. Public tours are also available for $5 and vertical tours let you climb a 124-step spiral staircase to the roof for $15.

> Cathedral Church of St. John the Divine is at 1047 Amsterdam Ave.
> Subway: 1 or 9 train to 110th Street/ Broadway.
> Call 212-316-7490.
> Visit www.stjohndivine.org

60. Columbia University

Campus life, specifically some stately buildings of higher learning—can be captured at Columbia University, located in the Morningside Heights neighborhood.

Cathedral Church of St. John the Divine. shot at 1/250, f 7.1, ISO100

Free tours of the campus are offered weekdays at 1 PM (10 people or fewer) and are open to students and the general public. Tours highlight prominent campus buildings including the Low Memorial Library (the tour departure point), the Butler Library, Revsen Plaza, and Casa Italiana.

Please be considerate of the students on campus.

At Broadway and 116th Street
Subway: 1 train to 116th Street/Columbia
 University.
Visit www.columbia.edu.

61. Riverside Church

Across the street from Grant's Tomb, Riverside Church is worth mentioning not only for its impressive gothic architecture, but also for its record-breaking attributes: at 392 feet, it is the tallest church in the United States. It also boasts the largest bell tower carillon in the world.

You can't help but capture the tower in the frame but intricate architectural sculptures and details abound and are worth a close-up, as is the interior labyrinth floor. Free tours are available after Sunday service. The church can also be captured from a Circle Line boat tour.

Riverside Church is at 490 Riverside Drive
 at 122nd Street.
Subway: 1 train to 116th Street/Columbia
 University.
Call 212-870-6700.
Visit www.theriversidechurchny.org.

The Upper East Side offers a mix of architecture, including these apartment buildings near Second and Third Avenues.

62. Grant's Tomb

Operated by the National Park Service, the General Grant National Memorial, better known as Grant's Tomb, offers a majestic Morningside Heights photo op. And as the old joke goes: Who's buried, or rather, entombed at Grant's tomb? Indeed Ulysses S., the 18th president, and his wife, Julia Dent Grant.

The granite-domed monument/mausoleum is considered the largest tomb in North America. A perfect row of trees in front adds fine perspective to the shot. Interior architectural details include ornate railings, trim, and the inside open portion of the dome. It's a quick visit. And as of a 1990s restoration prompted by a student from nearby Columbia University, it's now a well-kept space.

It's a good time to note that for this National Park Service property, a permit is required for photographing done by photojournalists and media within the boundaries of the particular site. The application costs $50. You can, however, take close enough shots from the perimeter of the grounds. If shots are for your own use, snap away.

> Grant's Tomb is at West 122nd Street and
> Riverside Drive.
> Subway: 1 train to 116th Street/Columbia
> University.
> Free admission.
> Call 212-666-1640.
> Visit www.nps.gov/gegr.

63. Harlem

Harlem photographic highlights offer busy storefronts, street scenes, building murals, and the landmark Apollo Theater and its famed marquee at 253 West 125th Street.

Of the many churches in the area, the Abyssinian Baptist Church, which celebrated its 200th anniversary in 2008, is perhaps the most famous. At 132 Odell Clark Place (West 138th Street).

Harlem Heritage Tours offers thematic walking tours of the neighborhood for about $20 to $40. Call 212-280-7888 for reservations.

Then, put the camera away and enjoy some of the best food in town. Soul, southern, and comfort food feasts can be had at Sylvia's Restaurant (328 Lenox Ave. between 126th and 127th streets, 212-996-0660); Melba's (300 West 114th St., 212-864-7777); Amy Ruth's (113 West 116th St., 212-280-8779); and Kitchenette Uptown (1272 Amsterdam Ave. at 122nd Street, 212-531-7600).

64. The Cloisters

The Cloisters branch of the Metropolitan Museum of Art is located way up in northern Manhattan on the four-acre Fort Tryon Park. The collection here emphasizes medieval art and architecture.

The building itself is part of the collection: It was assembled from architectural elements from the 12th to 15th centuries. The columns, archways, and cloistered medieval gardens make for a photo that will transport you back in time some six centuries.

The same photographic restrictions apply here as mentioned for the Met (see entry 55).

> The Cloisters are at 99 Margaret Corbin
> Dr.
> Subway: A train to 190th Street. Walk
> north along Margaret Corbin Drive for
> approximately 10 minutes or transfer to
> the M4 bus and ride north one stop.
> Suggested admission costs about $20 for
> adults (includes same-day visit to the
> Metropolitan Museum) or use your
> CityPass. Closed Monday.
> Call 212-923-3700
> Visit www.metmuseum.org/cloisters

The New York Botanical Garden lets you explore color at every turn.

General Description: After all of the excitement that Manhattan has to offer, the Bronx may seem a long way to go just to take a photo. That said, it is home to a world-class zoo and botanical garden as well as some surprising seaside scenes.

Directions: After Manhattan, we turn toward the outer boroughs in a clockwise manner starting with the Bronx, then Queens, Brooklyn, and Staten Island. Public transportation is available, but for the Bronx a car comes in handy. While subway stations are included with each entry, the Metro-North commuter train from Grand Central Terminal also services the botanical garden.

65. Yankee Stadium

The Bronx Bombers have some new digs in town.

The new Yankee Stadium opened to much fanfare in 2009. Architectural design elements include the Great Hall, Babe Ruth Plaza, and Monument Park.

Single-frame flash photography is allowed on site but the photos must be for private, non-commercial use as copyright is not given. Tripods and extended-length zoom lenses are prohibited, as are large backpacks. Patrons must also pass through security screening. In addition, it is an open-air stadium so prepare for inclement weather.

Press passes and press lounge use (located behind home plate) for working media are available by contacting the Media Relations Department.

The on-site New York Yankees Museum offers baseball-themed memorabilia and vintage photos.

Where: the northernmost borough of New York City
Noted for: Bronx bombers, urban flora and fauna, maritime magic
Exertion: minimal—moderate for walking
Parking: plentiful at Yankee Stadium, Bronx Zoo, and Botanical Garden
Eats: There's more than just hot dogs at the new Yankee Stadium, and some 30 restaurants on City Island.
Public Restrooms: at each entry mentioned
Sites Included: Yankee Stadium, Bronx Zoo, New York Botanical Garden, City Island
Area Tips: If you're unfamiliar with the area, guided tours and traveling with a friend are suggested.

By car take the Major Deegan Expressway (Interstate 87) to Exit 3, 4, or 5.
Subway: 4, B, or D train to 161st Street Station/Yankee Stadium.
Tickets range from about $14 to $375.
Guided game-day tours cost about $20.
Call 718-293-6000 (ticket office).
Visit www.newyork.yankees.mlb.com.

66. New York Botanical Garden

From welcoming winter orchids to delicate spring cherry blossoms, stately summer roses to remarkable fall foliage, the New York Botanical Garden promises a palette of color and floral detail any time of year. With some four dozen theme gardens on 256 acres there is a lot of ground to cover, but there's an inspirational photo op with every step. A macro lens comes in handy for closing in on some breathtaking blooms.

Amateur photography is allowed outdoors

This colorful Bronx Zoo resident, a red panda, preferred his snack to the photo session.

as long as you stay on the designated paths. Photography is permitted in the Conservatory but tripods and monopods are prohibited. Photography may be restricted during some popular exhibitions.

Media photography requests should be directed toward the Public Relations department at 718-817-8616. Commercial photo shoots are arranged through the Special Events department at 718-817-8657.

New York Botanical Garden is at Bronx River Parkway at Fordham Road.

By car: There are many access options— check the Web site or call.

By commuter rail: Take the Metro-North Harlem local line to Botanical Garden station.

Grounds admission costs about $6. All-access with Conservatory visit costs about $20. Parking costs about $12. Closed Monday.

Call 718-817-8700.

Visit www.nybg.org.

67. The Bronx Zoo

In a word—wild!

The Bronx Zoo is one of the world's premier city zoos. Here you'll find some 600 species of animals numbering 4,000 in all. It first opened its doors in 1899. Now a New York City landmark, the zoo attracts some 2 million visitors a year.

The furry, feathered, and scaly photo ops of note include lions and tigers and bears and an urban fauna repertoire from A (aardvarks) to Z (zebras) and everything in between. Resident alligators, elephants, flamingos, giraffes, gorillas, monkeys, and rhinos all present and accounted for. Please don't disturb the critters by using your flash.

For commercial photography, permission must be granted through the Wildlife Conservation Society Pubic Relations department at 718-220-5197.

The Bronx Zoo is at Fordham Road and Bronx River Parkway.

By car: For the Bronx River entrance (Gate B), take Bronx River Pkwy Exit 6.

Subway: 2 or 5 train to East Tremont Avenue/West Farms Square. Continue on Boston Road two blocks to the Zoo's Asia gate entrance. The BxM11 bus goes directly from Madison Avenue and 99th Street to the zoo.

Suggested admission costs about $15 for adults; pay what you wish on Wednesday. On-site rides, shuttle, and parking extra. Call 718-367-1010.

Visit www.bronxzoo.com.

68. City Island

Something of an urban anomaly, City Island is a small nautical world and surprising photo op unto itself.

Surrounded by the Long Island Sound and Eastchester Bay, at first glance the 1½-mile-by-½-mile island appears at times more Nantucket than New York, complete with marinas and yacht clubs, seaside sunsets, some 30 restaurants, a main street (City Island Avenue), historical buildings, two lighthouses, and tons of visitors every weekend. It's most conveniently reached by car.

The City Island Nautical Museum, open weekend afternoons, offers small maritime exhibitions and vintage photos of the island (190 Fordham Ave., 718-885-0008, www.cityislandmuseum.org).

The local resource for birdwatchers and photographers is City Island Birds (www.cityislandbirds.org).

By car: Take Cross Bronx Expressway (Route 95 North) to Exit 8B City Island.

Visit www.cityisland.com.

City Island adds maritime flair to your photos.

Queens County Farm Museum

General Description: For tourists, Manhattan and Brooklyn get all the glory. How about something a little different? How about horses, farmhouses, hens, Zen gardens, beaches, bird sanctuaries, and baseball—surprisingly, this is New York City, too. Bet you didn't expect that. And you'll find them all in Queens.

69. Belmont Park

Fans of horse racing as a photo subject should make their way to Belmont Park, home of the annual Belmont Stakes, the third leg of the Triple Crown.

Photography and tripods are allowed on site. And you may just win enough money to buy that new lens you've been dreaming of!

Belmont Park is on the Nassau-Queens border at 2150 Hempstead Tpke. in Elmont.

By car: Take Exit 26-D on the Cross Island Parkway.

Grandstand admission costs about $2; clubhouse admission costs about $5. Parking costs about $2. Prices are higher on Belmont Stakes race day.

Long Island Rail Road service is available to the track on certain days.

Another nearby option is Aqueduct Racetrack.

Call 718-641-4700.

Info on both parks is available at www.nyra.com.

70. Queens County Farm Museum

The Queens County Farm Museum is situated on a 47-acre parcel that has been used as farmland since 1697. The visit includes photographing a number of original New York City

Where: A bridge or tunnel ride from Manhattan, Queens hugs the Long Island–Nassau County border.

Noted for: a day at the races, remnants of a World's Fair past, the Amazin' Mets

Exertion: minimal–moderate (some walking; a moderate designation is given because of the possibility of getting stuck in frustrating car traffic—takes a lot out of you)

Parking: available at the sites mentioned

Public Restrooms: at most of the sites mentioned

Sites Included: Flushing Meadows Corona Park, Gateway National Recreation Center, Citi Field

Area Tips: There's a lot of ground to cover as entries mention photo ops throughout all corners of Queens. If you're taking public transportation or driving, allow extra time for local stops and traffic. Either way, bring a friend to help navigate the subways and streets of Queens.

subjects, including a vintage barn, a farmhouse, well-maintained crop fields, a maize maze in fall, and a variety of livestock and farm animals from geese to goats, pigs to peacocks. Annual events include an antique motorcycle show, a summer Indian powwow, and the Queens County Fair in mid-September.

Queens County Farm Museum is at 73-50 Little Neck Parkway in Glen Oaks.

By car: Take Grand Central Parkway to Exit 24 or the Long Island Expressway to Exit 32.

Farm open daily; inside farmhouse tours on weekends only.

Admission is free except during special
events.
Call 718-347-3276.
Visit www.queensfarm.org.

71. Gateway National Recreation Center—Jamaica Bay Wildlife Refuge & Broad Channel

Birdwatchers and nature photographers to the front of the line for a surprising city visit to the Jamaica Bay Wildlife Refuge, part of the New York and New Jersey Gateway National Recreation Center. These designated urban parklands are operated by the National Park Service.

The Jamaica Bay Wildlife Refuge boasts well-marked trails, some 9,000 acres of woodlands, saltwater marshes, ponds, and open bay all worthy of pristine nature shots, as well as more than 330 bird species. You can't miss the osprey nesting site. There are also a variety of reptiles, amphibians, and one of the largest populations of horseshoe crabs in the Northeast. Don't be discouraged by the Cross Bay Boulevard drive along the way—unfortunately

Jamaica Bay Wildlife Refuge, shot at 1/200, f 8.0, ISO 100

much of the road is strewn with litter (um, can somebody pick that up?).

The nearby Broad Channel neighborhood is a tight-knit community that adds narrow streets, seaside docks, and marinas to the frame.

By car: From the Belt Parkway take Exit 17,
Cross Bay Blvd. south to Broad Channel.
Subway: A train to Broad Channel. It's
three-quarters of a mile to the refuge.
Trails are open dawn to dusk. The visitor
contact station is open daily 8:30–5.
Call 718-318-4340.
Visit www.nyharborparks.org/visit/jaba.

72. Gateway National Recreation Center—Fort Tilden, Jacob Riis Park, and Breezy Point

The Queens Gateway tour continues to Fort Tilden, Jacob Riis Park, and Breezy Point, which are best accessed by car.

Fort Tilden is a former military base that offers abandoned buildings mixed into an oceanside setting complete with sand dunes and trails overlooking the Atlantic Ocean. The Battery Harris observation deck offers a bird's-eye panorama. A foggy day adds great atmosphere to the frame. A small parking lot on the north side of Rockaway Point Boulevard (just west of Beach Channel Drive) offers a perspective shot of decaying pier pylons and a view of the Gil Hodges Bridge over the Rockaway Inlet, which connects Brooklyn to Queens.

Jacob Riis Park, named after the journalist and friend of President Theodore Roosevelt, as well as Breezy Point offer more iconic beach scenes of sand, surf, dunes, and shoreline views of the Atlantic Ocean, where the sunsets can be magnificent. You won't believe you're in New York City. Riis Park adds a boardwalk scene as well. Here, protect your camera from the ocean mist and spray.

By car: From the Jamaica Bay Refuge,
continue west on Beach Channel Drive.

Fort Tilden, shot at 1/200, f 10, ISO 100

Or take the Belt Parkway to Exit 11S, Flatbush Avenue south, to the Marine Parkway Bridge toll plaza and cross the bridge.

Admission is free. Parking costs $5 a day at Riis Park from Memorial Day weekend through Labor Day.

Call 718-318-4300.

Visit www.nyharborparks.org.

73. Flushing Meadows Corona Park

Flushing Meadows Corona Park encompasses Citi Field, the Arthur Ashe Tennis Stadium, the Queens Museum of Art, and Hall of Science—the last two are highly recommended museum visits—and remnants of the 1964 World's Fair, a pretty big deal in its day.

The World's Fair remnants include *The Unisphere*, a mighty 140-foot-tall globe that sits atop a fountain built by U.S. Steel for the fair. Today it stands as an enduring city landmark. Add the soaring sculpture *Rocket Thrower* by artist Donald Delue, also built for the fair, into the Unisphere foreground shot or make him the worthy subject of his own photo.

Nearby and equally fun to shoot is the former World's Fair New York State pavilion/skating rink. Currently in a state of dilapidated neglect, the rink offers character to the frame in the form of a chain link fence, hints of graffiti,

and rusted peeling shades of butter yellow and light fuchsia paint. Plans are in the works to renovate the space, now the Queens Theater in the Park. Further south, Meadow Lake adds a 90-plus acre manmade pond to the photo.

Catch a Mets game, pack a lunch, visit the museums, take some photos, and spend the day.

By car: Take Grand Central Parkway to Exit 9E, Citi Field.
Subway: 7 train to Mets-Willets Point.
Call 311 for Parks and Recreation info or 212-639-9675 (212-NEW-YORK) outside of the city.
Visit www.nycgovparks.org

74. Citi Field

Citi Field replaces Shea Stadium as the new home of the New York Mets. In a word— Amazin'!

Architectural design elements include exposed steel trusses, the glass-arched Jackie Robinson Rotunda, and natural grass. It is an open-air stadium so protect your camera and be prepared for inclement weather.

Amateur sports photography is allowed. Photos must be for private, non-commercial use as permission to publish will not be granted. However, press passes and press lounge use (located behind home plate) for working media are available by contacting the Media Relations Department at 718-565-4330.

By car: Citi Field is in Flushing. Take the Grand Central Parkway to Exit 9E, Citi Field.
Subway: 7 train to Mets-Willets Point.
Ticket prices range from about $11 to $695.
Call 718-507-8499 (ticket office).
Visit www.newyork.mets.mlb.com.

75. The Noguchi Museum

Moments of minimalist Zen can be enjoyed and captured at the Noguchi Museum in Long Island City.

In his storied career, artist Isamu Noguchi (1904–1988) created abstract furniture, lyrical sculptures, and modest memorials of stone, metal, wood, and plaster. He also designed public gardens, fountains, playgrounds, and public art, which includes *Red Cube* (see entry 9).

Photography is allowed at the exterior courtyard garden and inside except for special exhibitions (flash is prohibited).

At 9-01 33rd Road at Vernon Boulevard, Long Island City.
Subway: From the Roosevelt Island Tram (see entry 42), walk north about a half-mile or take the shuttle to the Roosevelt Island Bridge. Cross the bridge to Vernon Boulevard, turn left, and walk north three blocks to 33rd Road (about 10 minutes). Sunday shuttle bus service from Manhattan to the museum costs $10 roundtrip. Check the Web site for more details.
Admission costs about $10 for adults; pay what you wish the first Friday of every month. Closed Monday and Tuesday.
Call 718-204-7088.
Visit www.noguchi.org.

Optional nearby car or cab visit: Venture about 15 blocks south along Vernon and head west toward 48th Avenue and Center Boulevard to Gantry Plaza State Park, a small concrete space that offers nice views of Manhattan.

Around the block is the Waterfront Crabhouse (2-03 Borden Ave., Long Island City, 718-729-4862) for casual seafood, burgers, steaks, and live music.

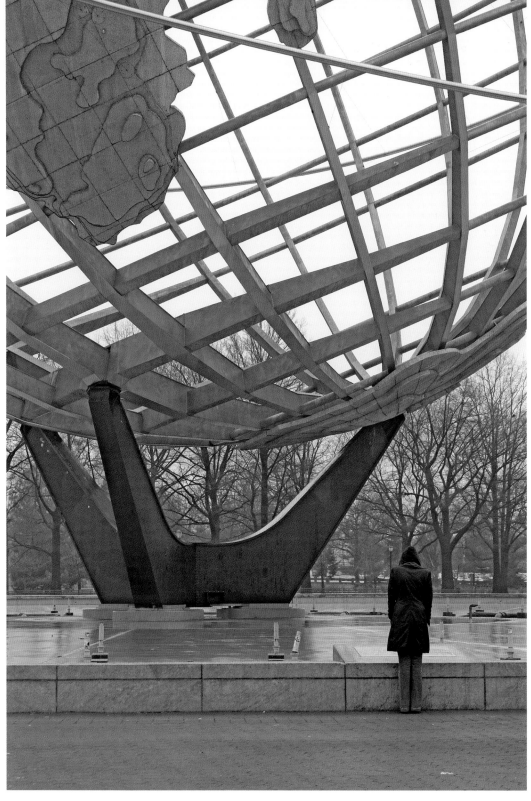

The Unisphere *at Flushing Meadows Corona Park*

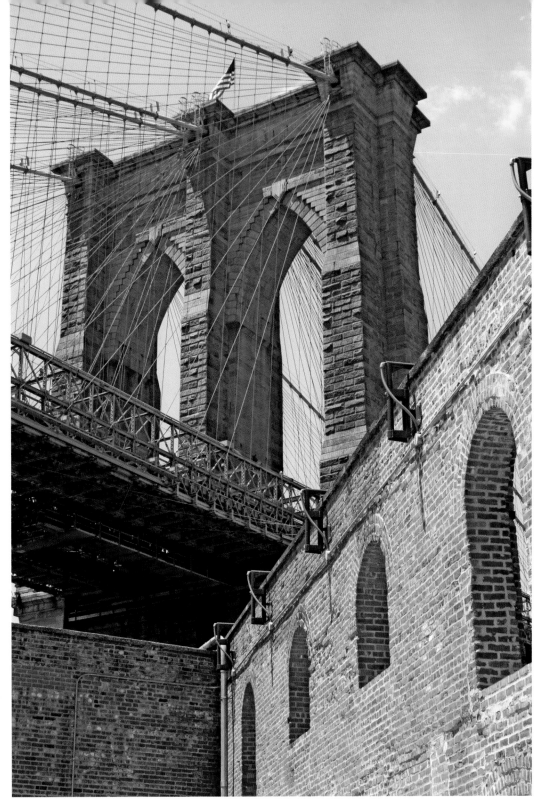

The Brooklyn Bridge from DUMBO

General Description: Its close proximity to downtown Manhattan will probably make Kings County, a.k.a. Brooklyn, the next most popular borough to visit for the tourist. Save a day for some special photo ops here—colorful Coney Island is alone worth the trip!

Directions: By car (for professionals only!) the Belt Parkway offers fairly easy access to Floyd Bennet Field, Coney Island, and New York Aquarium. Subway access from Manhattan to downtown Brooklyn, the Prospect Park/ Botanic Garden vicinity, and Coney Island is easily reachable and included with each entry.

76. Brooklyn Bridge/DUMBO

It's great to take a stroll across the Brooklyn Bridge with camera in hand—and it doesn't matter from which borough you start, Brooklyn or Manhattan. The famed bridge, which opened in 1883, makes the perfect photo subject on its own or adds an unmistakable element to New York City skyline shots.

Once in Brooklyn, venture to DUMBO— think SoHo and TriBeCa in terms of the neighborhood nicknames the city loves so much—it stands for Down Under Manhattan Bridge Overpass. Graduated from up-and-coming status, the established area offers trendy art galleries, bookstores, cafés, restaurants, and loft-style condos.

Usually overshadowed by its well-known neighbor, the Manhattan Bridge also offers its own unique architectural elements—from DUMBO at the intersection of Front and Washington streets you can squeeze the Empire State Building into a bridge archway for a fun street scene.

The area is also home to Empire-Fulton

Where: a short subway ride from downtown Manhattan

Noted for: boardwalks, beaches, bridges, and botanic bounty

Exertion: Minimal–moderate for walking. And this time there's a gentle incline (that's why they call it Brooklyn *Heights* and Park *Slope*).

Parking: If you thought parking in New York City was bad, wait until you meet Brooklyn.

Eats: Nathan's Famous hot dogs

Public Restrooms: at Coney Island, Brooklyn Museum, Brooklyn Library, Prospect Park

Sites Included: the Brooklyn Bridge, Coney Island, Brooklyn Botanic Garden, New York Transit Museum

Area Tips: I grouped the photo ops together: Coney Island and the New York Aquarium, Downtown Brooklyn and under the bridges, and Prospect Park and vicinity, which includes the library, botanic garden, and Brooklyn Museum.

Ferry State Park and Brooklyn Bridge Park, two adjacent waterfront spaces that provide plenty of room for taking photos and a small green foreground to the shot. Commercial photography (weddings) requires a city permit.

Pedestrian access to the Brooklyn Bridge in Brooklyn is available near Adams and Tillary streets, which border Brooklyn Heights and Downtown Brooklyn. (From Manhattan check entry 14).

Subway (for DUMBO): F train to York Street; A or C train to High Street.

77. Downtown Brooklyn/Brooklyn Heights

Brooklyn enjoys its own downtown area with plenty to see, do, and photograph, including

busy street strolls, prominent buildings, and roomy plazas.

The main courthouse combines the last two, complete with fountain and plenty of room for a tripod. Walk a block or two away to find some of the most gorgeous (and expensive) brownstones the city has to offer. For photographic inspiration stroll Clinton, Remson, Montague, and Pierrepont streets.

There are a number of surprising gems tucked down these side streets. One of my favorites is the art deco building at 185 Montague Street (I've yet to find its proper name, if it has one). Home to professional offices and a Mexican restaurant, I captured the façade from a side angle at the corner of Montague and Clinton streets during an afternoon stroll. I zoomed in for architectural detail in order to remove the retail signs from the shot—and boy

Art deco detail in downtown Brooklyn, shot at 1/320, f 10, ISO 100

did it work—a simple but stunning study of clean art deco lines.

> Subway: 2, 3, 4, or 5 train to Borough Hall (near the Courthouse).
> If walking from the Brooklyn Bridge, continue straight along the pedestrian walk to Tillary Street or Johnson Street and one block headed west to Cadman Plaza.

78. New York Transit Museum

Watch the closing doors!

The New York Transit Museum in downtown Brooklyn offers a variety of subway cars, train memorabilia, and vintage signage as the photo subjects of note. There are always some 20 trains on display. The museum space itself is the former Court Street subway stop, which was built in 1936.

Photography is permitted inside, but track access is prohibited (these railway lines are live!). It's OK to use the photos for your own noncommercial purposes. Permission must be granted for commercial-use photography.

> New York Transit Museum is at the corner of Boerum Place and Schermerhorn Street.
> Subway: 2, 3, 4, or 5 train to Borough Hall.
> Admission costs about $5 for adults.
> Closed Monday. A free gallery annex is at Grand Central Terminal in Manhattan.
> Call 718-694-1600.
> Visit www.mta.info/mta/museum.

79. Brooklyn Historical Society

Established in 1863, this Brooklyn Heights architectural gem inspires with an exterior study of color—you can't miss it, it's the rich terra cotta–colored brick façade that was so popular for the time and the area. Stunning details throughout include raised lettering (the building was originally the Long Island Historical

The Brooklyn Historical Society, shot at 1/80, f 5.6, ISO 800

Society); relief heads of Indians, mariners, and historical figures; and to perfectly offset that burnt orange hue, ivory-colored cornices. It's just magnificent.

Inside, the space offers a museum of exhibitions and a catalog of vintage photographs that well document Brooklyn's rich history.

> Brooklyn Historical Society is at 128 Pierrepont St.
> Subway: 2, 3, 4, or 5 train to Borough Hall; M or R train to Court Street.
> Admission costs about $6 for adults. Open Wednesday through Sunday.
> Call 718-222-4111.
> Visit brooklynhistory.org.

80. Park Slope

A few subway stops from downtown Brooklyn will lead you to the Park Slope part of Brooklyn. Of note here: rows of brownstone staircases that offer playful lines of perspective at almost every turn.

Within Park Slope proper you'll find the Park Slope Historical District, where Renaissance and Romanesque revival architecture rules. Many of these brownstones were constructed with the brickface mentioned above for the BHS and date to the late 1800s.

Here's an area itinerary: Start at the 14th Regiment Armory, a N.Y. National Guard unit and a national landmark building at 1402 Eighth Ave. between 14th and 15th streets; take a stroll through the historic district; visit Prospect Park; then venture to the Brooklyn Library, Brooklyn Botanic Garden, and Brooklyn Museum all mentioned next.

Delicious, fresh, and affordable Greek specialties can be sampled at Fez Café (240 Prospect Park West, 718-369-0716).

> Park Slope Historic District is bordered by Prospect Avenue to the north, Prospect Park West (or 9th Avenue) to the east, 15th Street to the south, and parts of 6th, 7th, or 8th avenues to the west.

The manmade Prospect Lake in Prospect Park is the only lake in Brooklyn.

Subway: 2 or 3 train to Grand Army Plaza;
F train to 7th Avenue or 15th Street-
Prospect Park stations.

81. Prospect Park, Grand Army Plaza, Prospect Park Zoo

The 500-plus acre Prospect Park offers a surprising dose of urban greenery complete with lake (add a fisherman or paddleboats to the foreground), hiking trails (add a horse to the shot), and grand archways and tunnels, which create fun silhouettes of passersby. The place is beautifully tranquil in summer and gorgeous in fall. The park was designed by veteran landscape architects Frederick Law Olmsted and Calvert Vaux of Central Park fame.

For architectural photo inspiration, the Grand Army Plaza entrance offers the Sailor's Arch. For furry friends in the photo, pay a visit

to Prospect Park Zoo, which is home to some 400 animals.

Grand Army Plaza entrance is at Flatbush
Avenue and Eastern Parkway.
Subway: 2 or 3 train to Grand Army Plaza;
B, Q, or S train to Prospect Park; B or
Q train to Parkside Ave; F or G train
to 15 St./Prospect Park.
Admission to Prospect Park is free. The
zoo costs about $7 for adults.
Call 718-965-8951.
Visit www.prospectpark.org.

82. Brooklyn Public Library

From Prospect Park's Grand Army Plaza entrance, you can't miss the magnificent Brooklyn Public Library.

The wonderful façade of the stylized Art Moderne 1941 building combines sleek sim-

ple curves, bold lines, and gold Egyptian hieroglyphics that pop on the impressive black front doors.

There's plenty of room to take shots from the library's main plaza as well as from Grand Army Plaza just across the street, just be careful of the busy traffic circle (don't worry, you'll hear the honking horns).

The Web site offers a fine collection of vintage Brooklyn photographs.

The Brooklyn Public Library is at Grand Army Plaza at Flatbush Avenue and Eastern Parkway.
Subway: 2 or 3 train to Grand Army Plaza.
Call 718-230-2100.
Visit www.brooklynpubliclibrary.org.

83. Brooklyn Botanic Garden

It's not as large as its Prospect Park neighbor, but the Brooklyn Botanic Garden offers 50 acres of refined gardens and horticultural inspiration year-round.

The photo subjects include serene garden strolls; Hanami, the Japanese art of admiring cherry blossoms every April through early May; a springtime serenade of colors along Magnolia Plaza; sumptuous summer shots in the Cranford Rose Garden; and 100 varieties of tropical water lilies and lotus at the Lily Pool Terrace.

Macro lenses come in handy for those beautiful floral close-ups. Tripods are allowed on the grounds.

Access at Eastern Parkway between the Brooklyn Library and Brooklyn Museum. Also access at 1000 Washington Ave.
Subway: 2 or 3 train to Grand Army Plaza; B or Q train to Prospect Park.
Admission costs about $8 for adults.
Closed Monday.
Call 718-623-7200.
Visit www.bbg.org.

The fountain at the Brooklyn Museum, shot at 1/200, f 7.1, ISO100

84. Brooklyn Museum

Adjacent to the Brooklyn Botanic Garden, the Brooklyn Museum impresses inside with its fantastic collection of fine and contemporary art as well as outside with its beautiful Beaux Arts exterior.

Interior photos without flash are allowed of the permanent collection. That said, the exterior, specifically the deceptively simple pulsating water fountain, which attracts curious kids of all ages, is the photo op that will keep you busy for a while.

> Brooklyn Museum is at 200 Eastern Parkway.
> Subway: 2 or 3 train to Eastern Parkway/ Brooklyn Museum.
> Suggested contribution of $10 for adults.
> Closed Monday and Tuesday.
> Call 718-638-5000.
> Visit www.brooklynmuseum.org.

85. Coney Island/Brighton Beach

Coney Island provides oceanside sensory overload complete with amusement park thrills, iconic roller coasters, a kaleidoscope of colorful neon signs, original architecture (some in various stages of dilapidation), boisterous buskers, beautiful bodies, and the occasional hot-dog-eating contest—what's not to love? That it's so far from polished makes it so special—there's a photo op with every turn and you will spend the day. What's for lunch? Nathan's Famous hot dogs, of course.

For a less frenzied boardwalk/oceanside feel, visit nearby Brighton Beach, less than a mile or so east along the boardwalk.

> Surf Avenue in Coney Island runs parallel to the boardwalk. The colorful boardwalk activity stretches for many blocks. A good starting point near the subway is Astroland Amusement Park between 10th and 12th streets.
> Subway: F, Q, N, or D train to Coney Island/Stillwell Avenue.

86. New York Aquarium

Will work for fish food.

The models at the New York Aquarium don't always stand still, but at least they eat! Resident penguins, sea otters, walruses, sharks, stingrays, and jellyfish rule the photo frame here. Permission for commercial photography purposes is required through the Wildlife Conservation Society, the operators of the aquarium as well as the Bronx, Central Park, Prospect Park, and Queens zoos.

> New York Aquarium is at Surf Avenue and West 8th Street in Coney Island.
> Subway: F or Q train to West 8th Street; N or D train to Coney Island/Stillwell Avenue.
> Admission costs about $18 for adults.
> Call 718-265-3474.
> Visit www.nyaquarium.com.

87. Floyd Bennett Field

Floyd Bennett Field was New York City's first airport when it opened in 1931. No longer an active airfield, the space is now part of Gateway National Recreation. Famous aviators who flew from Floyd Bennett Field include Howard Hughes, Amelia Earhart, and Douglas "Wrong-Way" Corrigan, who took off from the airfield in 1938 in the hopes of heading west on a cross-country U.S. flight. He wound up in Ireland. How's that for a wrong turn?

Current photo ops of note include a number of vintage aircraft as well as art deco architectural details at the Ryan Visitor Center.

> Floyd Bennett Field is at 50 Aviator Rd. Take the Belt Parkway to Exit 11S, then Flatbush Avenue south to the entrance.
> Call 718-338-3799
> Visit www.nyharborparks.org

Coney Island Wonder Wheel, shot at 1/200, f 8, ISO100

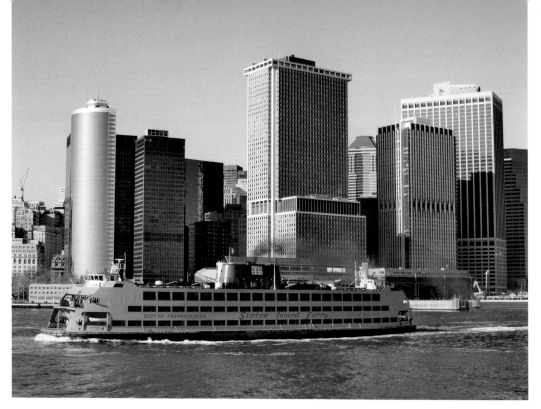

Staten Island Ferry with a Lower Manhattan skyline backdrop

Staten Island

General Description: The Richmond County borough of New York City, better known as Staten Island, gets a bad rap for being too far away from the glamorous city style of things. It's mostly residential and a thoroughfare for commuters between New Jersey and New York City. Here are some photo ops worth exploring.

Directions: By car from Brooklyn, take the Verrazano Narrows Bridge. By subway, make your way to the Staten Island Ferry in Lower Manhattan to connect with a number of Staten Island bus routes. The Staten Island Railway commuter line also provides service.

Where: a ferry ride from Manhattan or a bridge crossing from Brooklyn or New Jersey
Noted for: being the smallest borough in terms of geography and population.
Exertion: Minimal—you may drive for these as I did but public transportation is available.
Parking: at sites mentioned
Public Restrooms: at sites mentioned
Sites Included: Staten Island Ferry, Fort Wadsworth, Historic Richmond Town
Area Tips: If traveling by public transportation allow extra time to get to your destination. If traveling by car, rush hour and weekends can be busy. Bring a map or GPS.

88. Staten Island Ferry

The Staten Island Ferry provides service from Staten Island to Lower Manhattan for some 60,000 commuters daily. It also provides a panoramic photo op of Lower Manhattan for all. Best of all—this ride is free.

The Lower Manhattan skyline isn't what it used to be without the magnificent Twin Towers, but there are still some good shots to be had. Afternoon ferry rides leave the sun behind you when shooting toward Manhattan. The ferry itself, a bold splash of orange, makes its own colorful subject. The trip passes the Statue of Liberty on the way, but a zoom lens will be necessary. The ride lasts about 25 minutes.

Departs from Whitehall Terminal in
 Manhattan.
Subway: 1 train to South Ferry; R or W
 train to Whitehall Street/South Ferry.
Call 718-815-2628.
Visit www.siferry.com.

89. Historic Richmond Town

Historic Richmond Town re-creates New York City life circa the 19th century complete with costumed characters, 15 historical houses, and pastoral landscapes on a 100-acre site. Britton Cottage, the oldest house on the premises, dates to 1670. Most buildings—houses, taverns, barns, a courthouse, and a mill—date from the 1800s. Guided tours are held daily. You'll have no problem convincing the friendly staff to pose for the camera in front of these vintage structures.

At 441 Clarke Ave.
Admission costs about $5 for adults.
Call 718-351-1611.
Visit www.historicrichmondtown.org.

90. Fort Wadsworth

Part of Gateway National Recreation Area (also see the Breezy Point and Fort Tilden, entry 72) Fort Wadsworth offers spectacular Lower New York Bay views, span-tastic Verrazano Narrows Bridge perspective, and some gorgeous sunsets.

Strategic Fort Wadsworth has guarded New York Harbor for more than 200 years. Today, guests can visit and photograph Battery Weed, Fort Tompkins, and an overlook.

You can occasionally include migratory herons and hawks in the frame as well.

Continue the Staten Island tour a few miles to the south to arrive at two other Gateway parks: Great Kills and Miller Field, which add sandy beach shores and a marina to the mix.

Fort Wadsworth is at 210 New York Ave.
Visitor Center is open daytime hours
 Wednesday to Sunday.
Call 718-354-4500.
Visit www.nyharborparks.org/visit/fowa

91. Discover Staten Island Tour

Not enough time to view Staten Island properly? Opt for the Gray Line one-hour bus tour.

The tour departs from the St. George Ferry Terminal with stops and photo ops that include the Staten Island September 11 Memorial, Snug Harbor Cultural Center and Botanical Garden, the Staten Island Zoo, Clove Lakes Park, Fort Wadsworth, and the Alice Austen House Museum and Park.

Tours are available Friday, Saturday, and
 Sunday at 10 and 11:30 AM; and 1:15
 and 2:45 PM.
Admission costs about $15 for adults.
Call 800-669-0051.
Visit www.grayline.com for voucher
 ticketing rules.

Suggested Guided Tours & Special Events

New York City offers many tour options from well-established operators around for decades (Circle Line) and privately held neighborhood tours given by local city experts. Here's a mix of what's available. While many tours are on a timed itinerary, go with the tour flow, take note of the sometimes quirky history and subject info, and return to the scene of the shot if a particular theme strikes your photographic muse.

Helicopter Tours

For a truly thrilling New York City view, book a helicopter flight around the island of Manhattan.

Liberty Helicopter currently offers four tours that include a quick six-minute Statue of Liberty flight (about $150); a 15-minute Big Apple option that points out Manhattan landmarks and buildings (about $180); and a 20-minute five-borough tour (about $245).

New York Helicopter offers similar tours including a 15-minute Liberty Tour of Lady Liberty and the Financial District (about $139); a 20-minute Central Park midtown tour (about $206); and a 25-minute Grand Tour of the entire city (about $295).

Liberty Helicopter
Call: 1-800-542-9933 or 212-967-6464.
Visit: www.libertyhelicopter.com.

New York Helicopter
Call: 212-361-6060.
Visit: www.newyorkhelicopter.com.

Meeting Place: Tours depart from the VIP Heliport at Twelfth Avenue at West 30th Street on the Hudson River or the Downtown Manhattan Heliport, Pier 6 and the East River.

Circle Line Boat Tour

The iconic Circle Line has been a New York City sightseeing staple since 1945. If you're a New Yorker, you'll take a Circle Line tour at least once in your life.

The Circle Line cruises the waters around Manhattan daily and offers a leisurely way to capture some great skyline views. Get there early as the outdoor upper deck fills up first.

Tour options include the three-hour Full Island Cruise, which ventures entirely around Manhattan on the East and Hudson rivers. Points of interest include the city's seven major bridges, two dozen landmarks, and a close-up of the Statue of Liberty (about $34 for adults). The two-hour Semi-Circle Cruise concentrates on Lower Manhattan and includes the Statue of Liberty, the Brooklyn Bridge, and the United Nations (about $30). The two-hour Harbor Lights Cruise follows the Semi-Circle itinerary at dusk.

Meeting Place: Pier 83 at West 42nd Street and Twelfth Avenue.
Call: 212-563-3200.
Visit: www.circleline42.com.

Big Onion Walking Tours

Big Onion, one of New York's better walking tour outfits since 1991, is the brainchild of Seth Kamil, whose tour philosophy is to hire only doctoral candidates, college professors, and graduate students to lead guided neighborhood tours that informatively dish the dirt on New York City history inside and out.

Why the name Big Onion? Akin to the Big Apple nickname, "it's a metaphor for peeling away the layers of city history," Kamil says.

Public and private tours are held through-

out the city, cover from one to two miles, and last about two hours each.

Meeting place: Depends on tour.
Admission costs about $15 for adults.
Call 212-439-1090.
Visit www.bigonion.com.

Other Recommended Tours

Here are a few more free and paid walking and bus tours.

The Times Square Alliance offers free one-hour tours of one of the busier parts of town. It meets Fridays at noon at the Times Square Visitors Center, 1560 Broadway between 46th and 47th streets. Call 212-869-1890 or visit www.timessquarenyc.org.

The Municipal Art Society of New York offers fee-based (and sometimes free) tours with an emphasis on architecture. Tours cost about $15 to $30. Their weekly hour-and-a-half Grand Central Station tour is by suggested donation of $10. It meets at the main concourse information booth Wednesday at 12:30 PM. For complete schedule call 212-935-3960 or visit www.mas.org.

On Location Tours offers popular bus tours geared for fans of the big and small screen. Tours explore New York City in film and television, a Central Park movie site tour, and TV-themed tours. Most bus tours cost about $40.

Call 212-209-3370
Visit www.sceneontv.com.

Double Decker Bus Tours

New York isn't first when double-decker buses come to mind, but a number of companies offer the service. The tours provide orientation of the city and an elevated, unobstructed view, but you'll have to be quick with the camera (unless of course, you select a rush hour tour, which should slow things down enough for you to get a good shot). Gray Line and City Sights NY offer Hop-On/Hop-Off tours, which let you get off at any of the 50-plus stops, take your photo or visit an attraction, and then hop on the next bus.

The tour options run the gamut. Expect to pay from about $25 to $110.

Gray Line New York Sightseeing Bus Tours.
Meeting Place: Many tours depart from their visitors' center at 777 Eighth Ave. between 47th and 48th streets.
Price: about $49 for the 48-hour Hop-On/Hop-Off tour.
Call 1-800-669-0051.
Visit www.grayline.com.

City Sights NY
Meeting Place: Many tours depart from their visitors' center at 234 West 42nd St. between Seventh and Eighth avenues.
Price: about $54 for the two-day All-Around tour.
Call 212-812-2700.
Visit www.citysightsny.com.

Special Events/Spring Flings

New York City lends itself quite nicely to some annual special events worthy of attending and photographing. Some last a day, others a full week. Here's an all-season list of what may pique your photographic muse—but for a limited time only. Be prepared for a crowd at any of the following events.

It feels more like spring than winter, but the annual St. Patrick's Day Parade will have you seeing green every March 17 along Fifth Avenue. Beware the crowds of boisterous drinkers. Visit www.nyc-st-patrick-day-parade.org.

The annual Easter Parade and Bonnet Festival, complete with some very original colorful bonnets makes its way along Fifth Avenue near St. Patrick's Cathedral every Easter Sunday.

Summer Salutes

The Museum Mile Festival in early June turns Fifth Avenue into one big block party with free admission to nine museums. Visit www .museummilefestival.org.

The National Puerto Rican Day Parade kicks off summer with processions of colorful costumes again along Fifth Avenue. It's held in mid-June annually. Visit www.nationalpuerto ricandayparade.org.

Gay Pride takes to the streets of New York with a centerpiece pride parade held in late June. Skin, sequins, and rainbow memorabilia are the photo ops of the day. Visit www.nyc pride.org.

Macy's department store hosts an impressive annual display of fireworks every Fourth of July. The displays are usually seen along the East River.

Fall Follies

The German-American Steuben Day Parade adds colorful costumes to the parade mix in early September while many a marching band rules the Columbus Day Parade in mid-October.

Imaginations truly run wild at the annual Village Halloween Parade held along Sixth Avenue from Spring Street to 21st Street every Halloween. Some two million people attend. Visit www.halloween-nyc.com. If you prefer four-legged friends, Tompkins Square Park plays host to an annual Tompkins Square Halloween Dog Parade.

Fill the camera frame with colorful floats and fun character balloons during the Macy's Thanksgiving Day Parade, a tradition since 1924. Equally as fun is the inflation of the balloons the evening prior. The parade starts at Central Park West and travels south through Times Square, ending at Herald Square. Visit www.macys.com/campaign/parade.

Winter Wonderland

You may have to ditch the camera for this one. But for a massive sea of festive humanity, visit the dropping of the Times Square apple every New Year's Eve.

From colorful dragon parades to winter fireworks, the Chinese Lunar New Year is celebrated throughout the streets of Chinatown every January or February.

Practical Travel Info

When to Visit

New York City is busy all year round. And each season brings with it a variety of things to do and unique photo ops from orchids in winter, Easter bonnets in spring, baseball in summer, and fun floats come fall. A visit is recommended any time of year.

What to Bring

Besides your camera gear, casual clothes wear well in New York City. Comfortable sneakers or shoes are a must. Summertime often suffers from the three Hs—hazy, hot, and humid—so shorts and T-shirts are fine. A windbreaker comes in handy in spring and fall. And New York enjoys its own version of Old Man Winter. A warm coat and gloves are in order.

Getting Around Town—Public Transportation, Taxis

The extensive subway and bus system is not easy to master at first, but dive right in, you'll get it. Visit New York City Transit of the Metropolitan Transportation Authority, the MTA, for maps, prices, fun facts, safety tips, and more at www.mta.info.

The New York City Taxi and Limousine Commission is administered by New York City government. For current rates and consumer rights visit www.nyc.gov.

While great public transportation abounds, New York City, specifically Manhattan, is simply a great walking town. Don't forget to take the time for a stroll.

Safety

New York is one of the safest large cities in the world. That said, use your common sense. Travel with a friend. Don't flaunt your camera gear. Be aware of your surroundings—daytime and nighttime. And don't photograph someone who doesn't want their photo taken. Traveling with a seasoned tour guide for excursions off the beaten path is recommended.

Tourism Resources: Useful Telephone Numbers & Web Sites

I Love New York is the official statewide tourism resource. Call 800-CALL-NYS (800-225-5697) or visit www.iloveny.com.

New York City government offers tons of information for residents and tourists alike and also lists designated landmarks and historic districts in the city through its Landmarks Preservation Commission. Call 311 or 212-639-9675 (212-NEW-YORK) if calling from outside the city. Also visit www.nyc.gov.

NYC & Company, the city's official tourism bureau, provides guides, maps, and suggested itineraries. Visit online at www.nycgo.com.

The New York CityPass offers a reduced admission discount booklet to six area attractions and museums. Call 888-330-5008 or visit www.citypass.com.

Many museums offer their own free day of the week or month. Some museums accept "suggested contributions," a pay-what-you-can-afford policy (check with each museum for details).

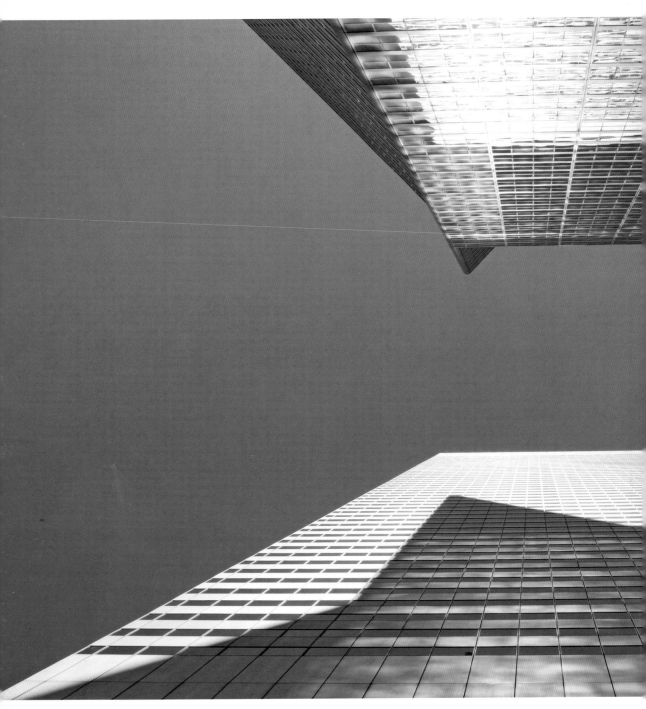

Look up! And bring a friend to help watch for oncoming traffic when standing in the middle of a New York City street! This shot of the Citigroup Center building (below) was taken from the middle of 53rd Street near Lexington Avenue.

Buildings

Municipal Building
IAC Building
Guggenheim Museum
Standard Oil Building
Chrysler Building
Flatiron Building
Storefront for Art and Architecture
Brooklyn Historical Society
American Folk Art Museum
Citigroup Center

Houses of Worship

St. John the Divine
St. Patrick's Cathedral
Eldridge Synagogue

Landmarks & Attractions

Coney Island
Brooklyn Bridge
Statue of Liberty

Picnic tables at Coney Island

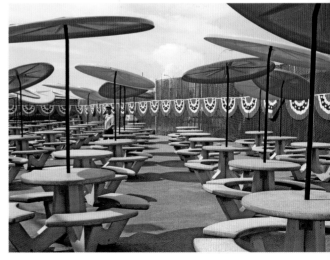

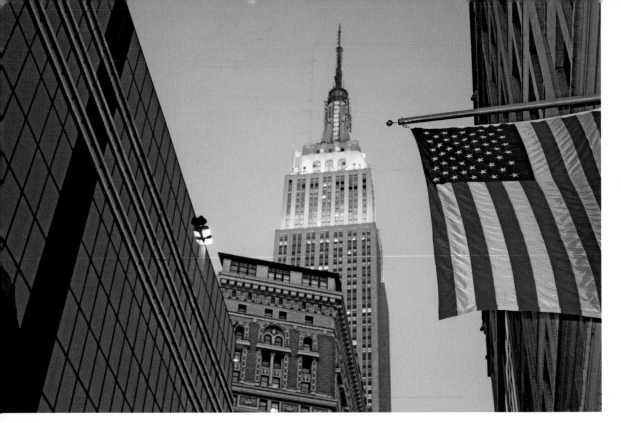

The Empire State Building at night

Sculptures & Public Art

Digital Clock Financial District
Water Display at the Brooklyn Museum
Christopher Columbus in front of the Time
 Warner Center
The Unisphere at Flushing Meadow-Corona
 Park

Streets & Strolls

Financial District/Civic Center
Soho . . . and Chelsea, Brooklyn Heights,
 DUMBO (OK, I love all of my
 neighborhood photo ops equally).

Greenery & Scenery

Central Park
Bronx Botanical Garden
Prospect Park

Brooklyn Botanic Garden
Staten Island Narrows & Breezy Point
 (Queens) shorelines—Life's a beach!

Views

From Top of the Rock
From the Circle Line: the complete tour
From the Roosevelt Island Tramway
From the Empire State Building Observatory
From a helicopter ride—if you can afford it!

Favorite Eats

Casual: Cowgirl for affordable Tex-Mex in the
 Village
Casual: Fez Café & Garden for fresh Greek
 food in Park Slope, Brooklyn
Pizza—any pizza in New York City as long as
 it's not a national chain